THE BOOK OF KELLS

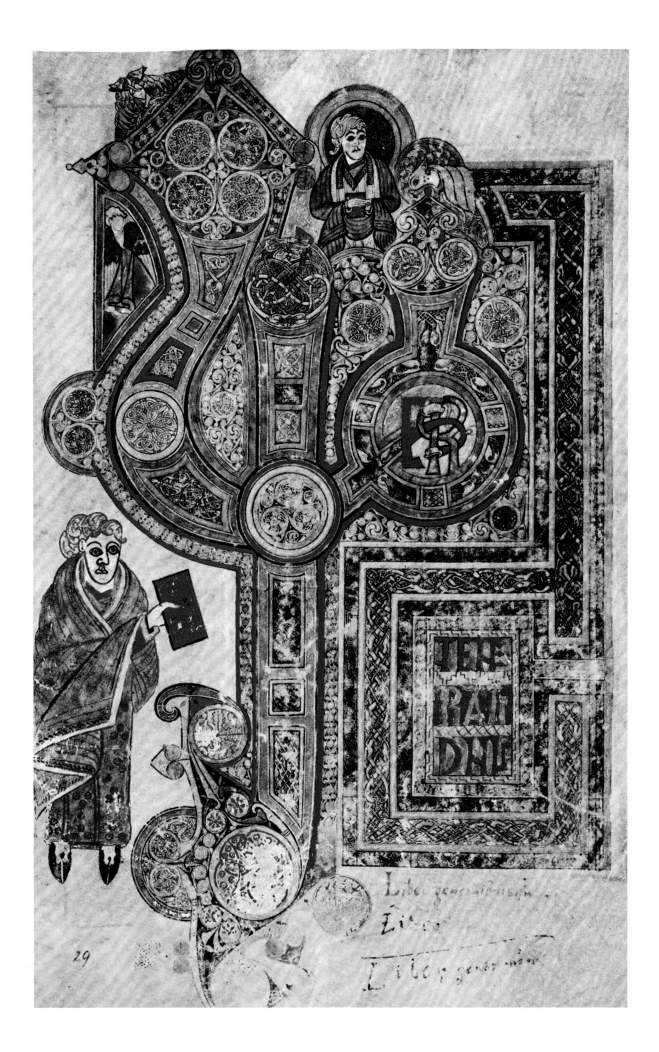

Liber generationis...

Liber

Liber generationis

29

THE
BOOK *of* KELLS

CHARLES GIDLEY

ARÍNA
BOOKS

Arina Books Inc.
2658 Del Mar Heights Road #162
Del Mar, CA 92014, USA

Copyright © 2011 Arina Books Inc.

Published in association with Konecky & Konecky, LLC.

ISBN: 978-1-937206-00-0

Printed and bound in China

Credits: frontis: f29r. The Introductory Page of the Gospel of Matthew;
at right: f. 34r Detail of angels from the Monogram Page;
far right: f.40v Detail from Beatitudes from the Gospel of Matthew;
images © visipix.com.

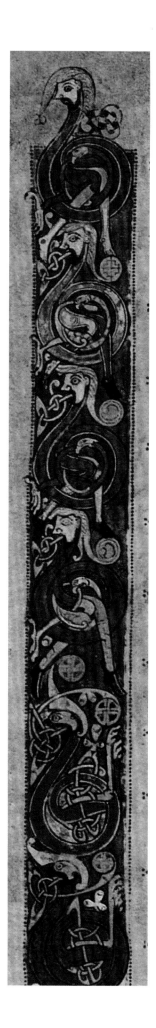

CONTENTS

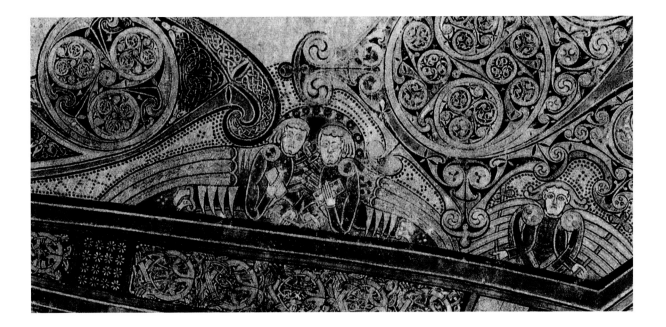

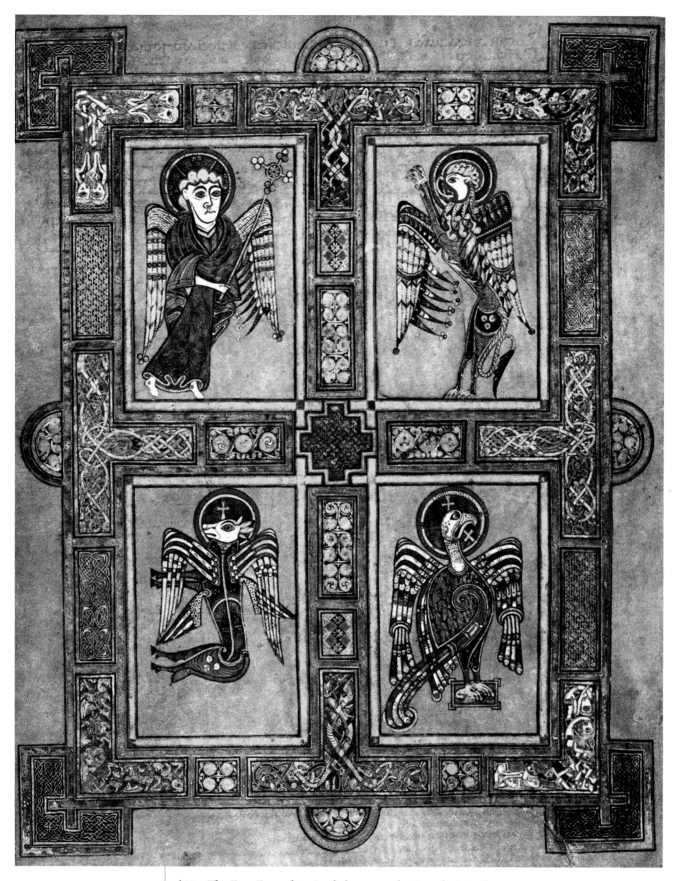

f.27v. The Four Evangelists Symbols page in the Gospel of Matthew.
The symbols of all four Evangelists are presented here. Reading clockwise:
Matthew (human), Mark (lion), John (eagle), and Luke (calf). ©VISIPIX.COM

INTRODUCTION

THE BOOK OF KELLS, Ireland's greatest national art treasure, is an illuminated manuscript that presents a Latin translation of the Four Gospels and their Preliminaries in a lush majuscule script accompanied by a dazzling array of decorative ornamentation, iconography, and illustration. The book is named after the Abbey of Kells in County Meath, Ireland, where it is believed monks associated with the monastic order of St. Columba in the late eighth to early ninth centuries created most of its pages. It is believed that the manuscript was never entirely completed. Scholars are unsure of its whereabouts immediately after the early ninth century Viking invasions, but most agree that it was still at Kells as of the early eleventh century. It remained there until Cromwell's invasion of Ireland. In 1654, during the occupation of Kells by Cromwell's troops, it was transferred for safekeeping to Dublin. In 1661 it was officially bequeathed to Trinity College. Under that library's stewardship and careful preservation the manuscript was elevated to the status it has today as Ireland's most hallowed work of art. The Book of Kells remains at Trinity and is on permanent display at the college's Old Library.

A first perusal of the *Book of Kells* can be a daunting experience, simultaneously mesmerizing and bewildering. The richness of its polychromatic artistry, the fecundity of its embellishment and the strangeness of it hieratic imagery can overshadow what the manuscript actually represents. It could be said that its artistry has the same kind of protean visual effect as modern-day Op Art or, in a more humorously popular vein, a session with a "Where's Waldo" book. Appreciation of many of the images requires a sustained contemplative focus accompanied by the use of a good magnifying glass. Only then will their shapes fully reveal themselves on the page. Even when images are clearly discernable, their meaning can escape the modern viewer. A working knowledge of each of the four Gospels is a prerequisite to overcoming these obstacles, as is a review of specific passages in the books of Ezekiel (1:1–29) and Revelations (4:1–8). These passages, which

will be referred to later in this survey, are thematically significant to the manuscript's symbolism and iconography. Finally, it will help to have a basic knowledge of manuscript's historical and artistic background. It is to be remembered that the manuscript is a presentation of the Four Gospels as envisioned by eighth and ninth century Columban monks, the understanding of whose culture and whose style of creating devotional art requires that we place the book in the context of the history of early Irish Christianity.

Scholars believe that Ireland's conversion to Christianity occurred during the fifth century. The first written reference to this conversion appears in a work known as *Prosper's Chronicle* and also in the *Annals of Ulster*, which state that in 431 Pope Celestine named one Palladius as the first bishop of Ireland. That Rome considered Ireland worthy of this recognition suggests that there must have been a significant number of Christian communities already present. Where the early missionaries who inspired these communities originated from is difficult to say. Some missionaries may have come via trade routes from Northern Spain, the Eastern Mediterranean or from Gaul. Some came from Britain. The most important of these was St. Patrick, who, according to the *Annals of Ulster*, arrived in 432. (After this we hear no more of Palladius.) For our purpose of describing the cultural milieu from which the *Book of Kells* emerged, it is instructive to note that the growth of Christianity in Ireland from the late fifth through the ninth century took two divergent paths. St. Patrick brought Romanized Catholicism to Ireland. Indeed, according to a fragment of one of his Latin letters, entitled *Confession*, Patrick thought of himself as a Roman citizen. His model of Christianity was the Church of Rome, a Church that reflected the urban environment in which it operated. Like the civil administration of the city of Rome, that Church took the form of a rigidly interconnected hierarchy based on centralized authority. When Patrick arrived in Ireland he found a loose confederation of rural Christian communities organized not around any central Church authority but rather around monastic centers, each independent from the other. Doctrinally, these communities were entirely in line with the Roman Church, but organizationally they formed the nucleus of what was to become a uniquely indigenous expression of Catholicism, which scholars have referred to as the Celtic or Irish Church. This monastic Irish Church was heir to a movement that stressed solitude, asceticism and scholarship, one whose roots can be traced as far back as the fourth century to North Africa's desert Fathers, the followers of eremitism in Syria and the Eastern Mediterranean, and to the monasticism in Gaul of St. Martin of Tours. Promulgated by a host of rather independent-minded monks, and therefore borderline renegades according to Rome, this breakaway monastic movement would have a tumultuous relationship with the rigidly organized Church of Rome as it spread through Western Europe and on to the British Isles.

The Patrician (or Roman) branch ultimately became Ireland's official church. However, from the sixth to the ninth centuries the monastic tradition of the Irish Church ran parallel to the Roman influenced organization created by Patrick and, most importantly, became fertile ground out of which grew a uniquely Irish community of monks. Hungry for Latin religious writings of the Church Fathers, this community became known for its devotion to scholarship, learning, and art, and it was this devotion that inspired them to create a repository of classical Latin

learning during the barbarian invasions of the Dark Ages. With much of Western Europe sunk into illiteracy, it was the monks of this Irish Church who kept the lamp of classical scholarship lit in the capacious libraries and thriving scriptoria of their monasteries. And it was in their scriptoria that illuminated manuscripts like the *Book of Kells* were created. In a sense, these illuminated manuscripts, the crown jewel of which is the *Book of Kells*, were emblematic of this heroic effort. Of these monasteries, none were more influential than those created by St. Columba, whose missionary activities in Ireland and Scotland helped create a network, which came to be known as the Columban Community.

Born in 521 in modern day County Donegal, St. Columba (Colum Cille) studied under St. Finian at the influential Clonard Abbey in County Meath where he became the member of an elite group of students known as the Twelve Apostles of Ireland. After his ordination he proceeded to create monasteries modeled on Clonard throughout Ireland. One of these was at Kells. Around 560 he quarreled with St. Finian over the ownership of the manuscript of a Psalter that he himself created. (This manuscript, based on St. Jerome's translation of Psalms, is known as the *Cathach of St. Columba*.) Shockingly, this disagreement resulted in a pitched battle between opposing monks that resulted in a number of deaths. Horrified at this tragedy, in 563 St. Columba sought atonement with a self-imposed exile to the island of Iona off the northwestern coast of Scotland. It was here that he founded a monastery from which he carried his missionary activities to

The ruins of the monastery of Iona. Iona was the center of St. Columba's missionary activities.

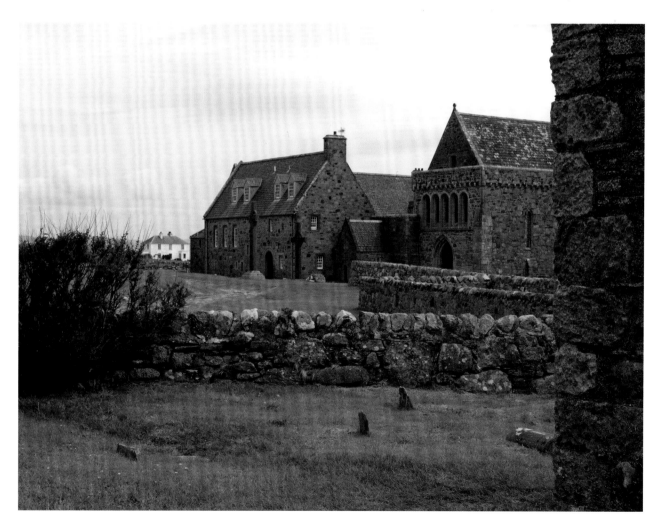

the Picts, leading to the subsequent conversion of Scotland to Christianity. Iona became the center of not only the Columban community but also of a monastic movement that would be carried by Irish monks throughout the British Isles, Northern France, Italy, and Switzerland. These monasteries produced a number of illuminated manuscripts, referred to by scholars as the Insular Manuscripts. And it is in the scriptorium of Iona, just before Viking invasions of the late eighth and early ninth centuries, that the story of one of these manuscripts, the *Book of Kells*, may have begun.

The *Book of Kells* occurs late in the cycle of these Insular Manuscripts, which were created from the late sixth century through the early ninth centuries. They are referred to as *insular* because they were products of monastic scriptoria located mainly on what was thought of by continental Europe as the "islands" of Britain, Ireland, and Scotland. These manuscripts were largely presentations of the Gospels rendered in an *illuminated* style. Illuminated refers to manuscripts

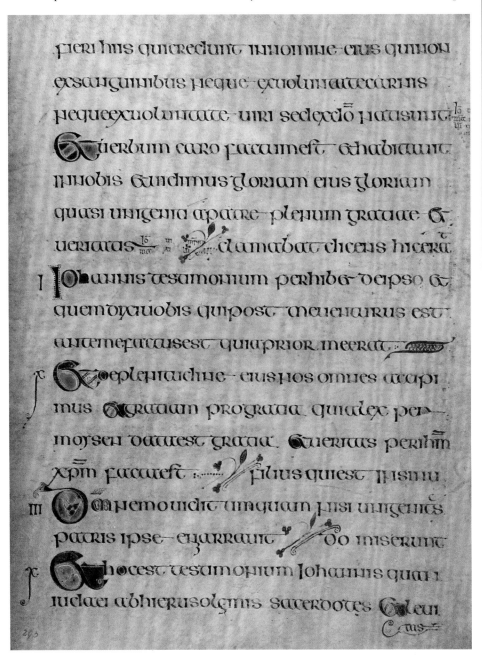

f.293v. Example of insular majescule taken from the Gospel of John. ©VISIPIX.COM

whose text was embellished with decoration, such as dramatically ornate initials often accompanied by variously colored images, interlaced shapes and illustrations. The term "illuminated" is, strictly speaking, generally used by paleographers in designating manuscripts whose decoration and script are rendered in gold leaf or silver. Although the *Book of Kells'* missing covers may have been adorned with these precious metals, their cost made use in the manuscript's pages prohibitive. The text of the Insular Manuscripts employed a script called *insular majuscule* and *insular miniscule.* In general, majuscule is uppercase letters and miniscule is lower. Majuscule was the predominate style with miniscule used at the ends of lines and most commonly with letters "e" and "s". Usually, although not always, these letters were transcribed in a brownish iron gall ink. Irish monks developed this insular script, also known as Irish script, when translating Roman texts brought to Ireland by missionaries during its conversion to Christianity in the fifth century. Of the works considered part of the Insular Manuscript group, the earliest may have been the *Cathach of Columba* (cited above). From the seventh century come the *Ambrosiana Osorio's* and the *Book of Darrow. MS A. II 17* in the Cathedral Library of Durham, the *Echternach Gospel*, the *Book of Lindisfarne*, and the *Litchfield Gospels* are all believed to be products of the early eighth century. Works created in the late eighth and early ninth centuries, contemporaneous with of the *Book of Kells*, are the *Gospel Book No. 51* from the Cathedral Library of St. Gall, the *Book of Mac Regol*, and the *Book of Ramah.*

Exactly when and where the *Book of Kells* was created remains in dispute. Theories as to when the book was compiled range from the time of Columba to various theoretical dates between the sixth and ninth centuries. Nowadays scholars are in general agreement that it was the product of Columban monks, and analysis of its text and imagery suggest that it was begun at the end of the eighth century. One theory holds that it was created to commemorate the bicentennial of St. Columba's death in 597. This would suggest that it was begun some time before 797. How long the project took is also unclear. In fact the manuscript may have never been finished. But the general time frame assigned to its production is some time between the years 790 and 820. Scholars also disagree as to where it was created. One theory suggests that it was written at Iona and then brought to Kells unfinished but never completed. Another, that it was begun at Iona and completed at Kells. And there are scholars who believe that it was produced entirely at Kells or at some other monastery, perhaps Lindisfarne off the northeastern coast of England. The Iona-to-Kells theories have the most adherents. This connection provides a credible scenario of why and when the manuscript ended up at the Kells monastery. In 795 the Abbey at Iona suffered its first in a series of Viking raids that, by 825, would destroy it. Scholars theorize that the besieged monks fled to Kells, bringing the manuscript with them. Kells then became the new center for the Columban community. In so far as the Viking raids did not afflict Ireland until the late ninth century, it is possible that the manuscript could have been written during this relatively long period of peace.

Although the manuscript's presence at Kells as of the late eighth century continues to be, at best, a reasonable speculation, it was almost certainly there in the beginning of the eleventh century. Evidence of its whereabouts is alluded to in the *Annals of Ulster*, which in 1007 records:

…the great Gospel of Columkille (Columba), the chief relic of the Western World, was wickedly stolen during the night from the western sacristy of the great stone church at Cenannas (Kells) on account of its wrought shrine.

The chronicle goes on to note that the book was found nearby some two months later buried under sod, its wooden and gold metalwork covers torn off. This violent handling would account for the fact that a number of pages at the beginning and end of the book are missing. That the *Annals of Ulster* refers to the purloined manuscript as the "Gospel of Columba," leaves little doubt as to this artifact being the *Book of Kells*. And at Kells it remained until its aforementioned transfer to Dublin and Trinity College during Cromwell's invasion of Ireland in the mid-seventeenth century. Today, at Trinity College's Old Library, sections of the manuscript are presented in rotation, each temporary display presenting a specific Gospel and selections of the book's breathtaking illuminated pages. What then is the make-up of the pages in this rarest of manuscripts?

The *Book of Kells* is a translation of the Four Gospels and their Preliminaries transcribed onto leaves made of calf vellum, a medium used in other Insular Manuscripts. (It is estimated that the *Book of Kells* required the processed hides of nearly one hundred and fifty calves). These leaves are referred to as folios. A folio is single leaf whose front is called the *recto* and whose back is called the *verso*. When viewed in the book, the recto appears on the right and the verso on the left. The pages can also be made of *bifolios*, that is larger sheets of vellum folded over to form two pages with two rectos and two versos. These pages are gathered and

St. Columba's church, graveyard, and roundtower in Kells, Co. Meath.

stitched together into what are called *quires*. The present manuscript consists of 340 folios or 680 pages. It is possible that the original had 370 folios (740 pages). Due to its covers having been torn off when it was stolen in 1007, the front of the manuscript may be missing as many as ten folios. In the back there are four chapters missing from the Gospel of John. From the book's interior are missing two portraits, one of Mark and one of Luke, and a "four Evangelists symbols" page (to be described in a later section) from the Gospel of Luke. Other pages may have been removed by the manuscript's creators for further work and then never replaced or simply lost over the centuries.

Compared to other Insular Manuscripts, the *Book of Kells* is quite large. Today it measures 13 x 9½ inches. It originally may have measured 14½ x 10¼ inches, but unfortunately it lost the top section of its pages, and therefore some of their ornamentation, during a poorly executed rebinding process in the late eighteenth century. Rebound numerous times before and after that mishap, the manuscript received the competent care it deserved when in 1953 it underwent a complete restoration and was reformatted into its current incarnation of four volumes under the expert direction of the British bookbinder Roger Powell. Renowned for his fine work with many other historical manuscripts, Mr. Powell was awarded the Order of the British Empire (OBE) in 1976.

The text of the manuscript is mix of translations. Some sections feature a pure transcription of the *Vulgate,* while others are rendered in various forms of what is known as Old Latin, or *Vetus Latina.* The Vulgate Bible was in major part the work St. Jerome who in 382, at the behest of Pope Damasus I, revised Old Latin versions of the Bible, based upon Greek and Hebrew manuscripts. Others participated in what would become a complete revision of the Bible along the lines of St. Jerome's methodology. This Vulgate Bible came to be known as the *version vulgate,* or "commonly used translation," and was eventually recognized by the Roman Catholic Church as the official text of the Bible. Old Latin versions would have been familiar to Columban monks. They were a legacy of the translations of Roman texts handed down from the earliest missionaries who began Ireland's conversion to Christianity in the fifth century. It has been surmised that, for whatever reason, the manuscript's scribes would depart from the Vulgate text and, perhaps working from memory, insert passages of Old Latin text. Of course, very few modern viewers are preoccupied by the subtle differences in the Latin text; for them the book's chief attraction is its remarkable artwork. The often puzzling meanings of this artwork can be made clearer when placed within the context of the book's main sections, a general survey of which follows.

The *Book of Kells* is divided into two main sections: the Preliminaries and the Four Gospels. The Preliminaries, the use of which were a common motif in the Insular Manuscripts, serve as prefatory material for the Gospels and begin with the manuscript's first extant folio, a list of Hebrew names (f. 1r). This is followed by the Canon Tables (ff. 2r–6r), the *Breves causae,* and *Argumenta* of the Evangelists (ff. 8r–25v). The Gospels themselves begin with, of course, the Gospel of Matthew (f. 27v). Before the text of each Gospel commences, there appear a series of full-page illustrations, the most common being the symbols of all four Evangelists, a portrait of the Gospel's Evangelist, and a full page of decorative text on which the Gospel's opening words are transcribed. Additionally, in some

instances, as the Gospel stories progress we find full-page illustrations depicting a particular passage in the text. Not all the Gospels have all of these elements. The reasons for these absences will be discussed under each Gospel's sub-section.

List of Hebrew Names

There are two lists of Hebrew names, and these are only fragments. The lists contain the Latin translations of Hebrew names that appear in a specific Gospel. Of the two partial lists remaining, one pertains to the Gospel of Matthew (f.1r) and the other to the Gospel of Luke (f.26r–v) Lists for Mark and John are missing. The list associated with Matthew is the *Book of Kells'* first extant page and appears to be the end of a longer list of Hebrew names. The list for Luke seems to be out of place, appearing many folios into the book, following the *Breves causae* for the Gospel of John. As the first page that the viewer comes upon in the book, the artistic presentation of the list for the Gospel of Matthew is instructive. Its architectural framing, filled with complex interlacing and other curious embellishments, is a preview of what is to come in an even more elaborate fashion as the book progresses. So too is the page's quirky layout: on the left is a straightforward list of Hebrew names while on the right is an odd and practically indecipherable rendering of the symbols of all four Evangelists. To see them properly, one has to turn the book with the right side of the page facing downward and even then the order of presentation from left to right is out of sequence: Luke, John, Matthew, and Mark. Why all four Evangelists are presented here when the list pertains only to Hebrew names in Matthew is the kind of visual non sequitur with which the book is replete. The artists' deliberate addition of these seemingly whimsical presentations will be considered in our section discussing the book's symbols and themes.

The Canon Tables

The Canon Tables, also known as the Eusebian Canons, are numbered indexes cross-referencing passages in the four Gospels that refer to the same incident in Christ's life. There are technically ten such tables, but only eight are fully illustrated cross-referencing indexes, presented in a motif known as an "arcade." Of these eight arcades the first two represent Canon Table I (ff.1v, 2r) and show the mutually occurring passages in all four Gospels. Canon Table II (ff.2v, 3r) cross-references only those passages common to Matthew, Mark, and Luke. The following page, folio 3v, is one of the book's most puzzling because it depicts not only the final list of Canon II but, oddly, a very compressed index of Canon Table III, which contains passages common to Matthew, Luke, and John. Canon Table IV (f.4r) refers to Matthew, Mark, and John. Canon Table V (f.4v) interrelates Matthew and Luke. Canon Tables VI, VII, and VII (f. 5r) present passages found in Mark and Luke. The two remaining Canon Tables, IX and X, (ff. 5v, 6r) are not presented as arcades but in simple columns separated by thin bands of color and are relatively devoid of ornamentation. Canon Table IX interrelates passages in Luke and John, and Canon Table X presents passages common to all four Evangelists.

The system of cross-referenced indexes, or "tables", was devised around 320 by one of the Catholic Church Fathers, Eusebius of Caesarea, who sought to

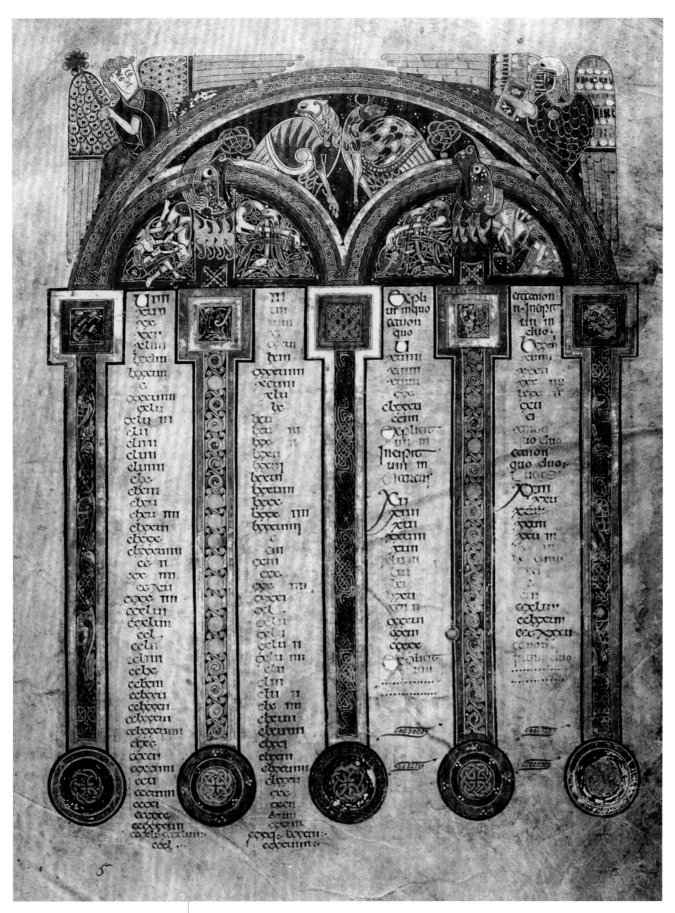

f.5r. Canon Tables VI, VII, and VIII. This page displays the combined indexes for Mark and Luke, whose symbols appear in the tympanum. In a rather dramatic artistic flourish, the imposing symbols of Matthew and John appear atop the arcade's frame. ©VISIPIX.COM

"harmonize" the Gospels by showing congruities and differences in the accounts of Christ's life from one Gospel to another. These Canon Tables became standard prefatory material to most Latin versions of the Gospels. St. Jerome used this Eusebian system as an indexing device in his Vulgate translation, which, as we have seen, was only one of the Gospel translations used in the *Book of Kells*. The Canon Tables' numbering system was accommodated by St. Jerome to the chapters and verses of his version but could not be synchronized with the *Book of Kells'* use of various Old Latin translations because, line by line, the passages of these translations could be shorter or longer or even in slightly different order than those of the Vulgate. That the Canon Tables numeric designation of a particular Gospel passage was in sync with the Vulgate version but not with the Old Latin renders the Eusebian system useless as a practical indexing device in the *Book of Kells*. Just as Canon Table III seems haphazardly jammed into the end of what begins as the continuation of Canon Table II (f.3v), the very inclusion of Canon Tables that serve no practical purpose to the manuscript has suggested to some that the creators of the *Book of Kells* were, at best, careless, or worse, irresponsibly indifferent to the relationship between the manuscript's textual content and its art work. We hope to show that such accusations are unfounded.

The Breves causae and the Argumenta

The *Breves causae* are taken from pre-Vulgate Gospels and serve as summaries of each Gospel's content. The *Argumenta*, also pre-Vulgate, are collections of legends about the Evangelists. This section of the Preliminaries opens with the *Book of Kells'* first full page illustration, the Virgin and Child (f.7v). This is the first known representation in a Western manuscript of this significant iconographic motif. Also, it is here that we are introduced to what are most likely the four archangels Michael, Gabriel, Raphael, and Uriel, whose images appear throughout the manuscript and whose thematic importance will be discussed later in this survey. The Virgin and Child page is cleverly paired with its facing page (f.8r), whose ornamented text features the opening line of the *Breves causae* of Matthew: *Nativitas XPI in Bethlehem Judaea; Magi munera offerunt et infantes interficiuntur; Regression* ("The birth of Christ in Bethlehem of Judea; the wise men present gifts; the Massacre of the Innocents; the return"). Aside from this unique introduction to the *Breves causae* of Matthew the general technique of this section's entries is to begin each entry with highly elaborate initials spelling out the Evangelist's name. The heading for the *Argumentum* of Matthew (f.12r) is a good example of this approach.

The logical order of these chapters should be the Evangelist's *Breves causae* followed by his *Argumentum*. Starting appropriately enough with the first Evangelist, Matthew (f.8r), the presentation proceeds in a disordered fashion ending with folio 25v, the last page of John's *Breves causae*. The summaries and legends of Matthew and Mark appear in order but are then followed, inexplicably, by the *Argumenta* of Luke and John, the *Breves causae* of Luke and finally the *Breves causae* of John. Why this occurred remains open to speculation. This disordered presentation does not exist in any of the other Insular Manuscripts except for the *Book of Durrow*, in which the sequence of these chapters is almost identical to the sequence in the *Book of Kells*. Some scholars have suggested the possibility

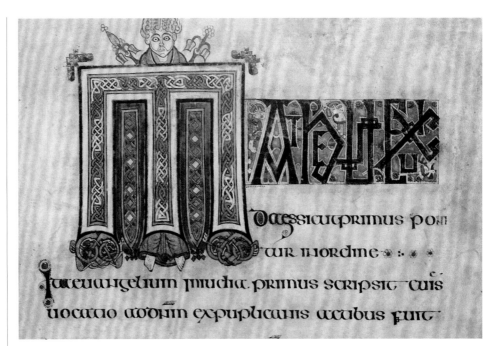

that the Kells' scribe, who may have had access to the *Book of Durrow* in his abbey's library, simply copied that older manuscript's presentation.

Although we cannot know the real reason for the disordered sequence in which these chapters are presented, we can offer a credible assumption as to why the *Breves causae* and *Argumentum* of each of the four Evangelists have been put in the Preliminaries section and not, as they are in other Insular Manuscripts, separately as prefatory material to each Evangelist's Gospel. Although the scribes and artists of the *Book of Kells* could sometimes be careless with their presentations of human inventions (Canon Tables, *Breves causae* and *Argumentum*) they were far stricter with the sacred text of the Gospels and seemed determined to keep them free of any intrusions that would compromise the purity of the Holy Word.

The Gospels

As alluded to above, preceding the text of each Gospel there may have been a standardized plan for the prefatory pages that included first, a page of the four Evangelists symbols, followed by a portrait of the Evangelist, and then a fully decorated page depicting the Gospels opening verses. Whether such a general plan for the book actually existed remains in question because not all of the Gospels have each of these prefatory elements. It is possible that some of the missing pages were part of the original manuscript but were at one point extracted, perhaps to be worked on, but then never replaced.

The Gospel of Matthew (ff.27v–129v) has a full complement of these prefatory pages: four Evangelists symbols (f.27v), portrait of the Evangelist (f. 28v) and the Introductory page (f. 29r), which begins with the words *Liber generationis*. The introductory page, which features an image of the Evangelist in the upper frame, represents the opening verses of the Gospel of Matthew's genealogy of Christ. And it is here that Matthew stands out from the manuscript's other three Gospels. In Matthew the genealogy verses are set off from the Gospel's subsequent verses by the addition of two unique illustrations that are not part of the standard presentation

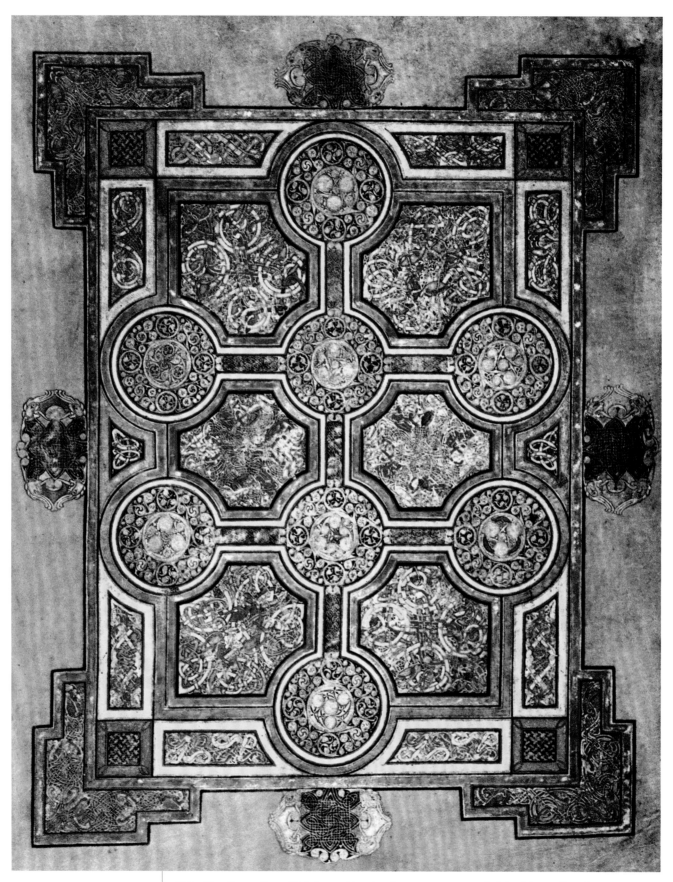

f.33r. The Carpet Page. This is considered to be an aniconic symbol for Christ. Note the profusion of "triskelia" and triple spirals, ancient Celtic symbols for the cycle of birth, life, and death, as well as the page's presentation of the cruciform motif. As a composite image of Christian iconography this page symbolizes human salvation through Christ's Crucifixion and Resurrection. ©VISIPIX.COM

elements. Following the genealogy text is the *Book of Kells'* only full portrait of Christ (f. 32v) facing the book's only "Carpet" page (f.33r). This is also referred to as the "Eight-circled Cross" page. Carpet pages are fully ornamented representations of precisely balanced geometric patterns, densely embellished with discs, spirals and interlacing. These somewhat mysterious artistic forms may have had their origins in Coptic and Oriental art. They do appear in other Insular Manuscripts, the earliest being in the seventh century *Ambrosiana Orosius*, as well as in the *Book of Durrow* and the *Lindisfarne Gospels*. As if to purposely present the genealogy in Matthew (Matthew 1:1–17) as separate from the rest of the text, the continuation of the Gospel, beginning with *Christi autem generatio* (Matthew 1:18) is set off from the genealogy pages with what could be referred to as a second introductory page. This is the Monogram page (f.34r, the frontispiece of this book), which is one of the *Book of Kells'* most remarkable artistic achievements. Embedded in the ornamentation of this page are the Greek initials XPI or Chi-Rho-Iota, the first three letters of Christ's name, and the word *autem*. The third word, *generatio*, appears beneath the spectacularly ornamented letters on the lower right.

The next full page representation after the Monogram page is one of the illustrations referred to above that depict a particular incident in the Gospel's text. This is the Arrest of Christ (f.114r), which follows the passage in the text of Matthew 26:30. ("And after reciting a hymn, they went out to the Mount of Olives.") On the verso of this illustration is a full page of decorated text (f.114v) referring to the immediate aftermath of the arrest in which appears the passage *Tunc dicit illis IHS omnes uos scan[dalum]*. ("Then Jesus said to them: you will all be scandalized.") There is next another page of decorated text (f.124r) relating to the Crucifixion with the passage *Tunc crucifixerant XPI cum eo duos latrones*. ("Then were there two thieves crucified with him.") Scholars note that the page facing this crucifixion passage, which is folio 123v, has been left blank. It is surmised that a full-page illustration depicting the Crucifixion was intended for this blank page but was never done.

Finally, there are two blank pages worth noting. The first, f.28r, is opposite the four symbols page (f.27v). As can be seen, it is not entirely blank but features a ghostly, pentimento-like image of a standing figure. The image is, in fact, from the portrait of Matthew (f.28v), which has partially bled through the vellum. A similarly vague outline appears on the verso (f.33v) of the Carpet page (f.33r). The thickness of a particular folio's vellum, the chemical make-up the paint, the binding substances used, and the drying process are the causes of these faint mirror images.

The Gospel of Mark (ff.129v–187r) begins with a four Evangelists symbols page (f.129v) and an Introductory page (f.130r). Missing from this Gospel is a Portrait page. Whether this was lost or simply never done remains in question. Embedded in the decoration of the Introductory page is a figure symbolizing the Evangelist (on the upper right) and the opening words in the Gospel of Mark: *Initium Evangelii Ihu XPI* ("The Beginning of the Gospel of Jesus Christ"). Also in Mark are two pages of ornamented text. The first represents the Crucifixion, Mark 15:24–25 (f.183r) and bears the words *Erat autem hora tercia* ("Now it was the third hour"). The other page occurs at the end of the Gospel (Mark 16:19), which concerns the Ascension (f.187v). The design of this page has puzzled scholars because its layout recalls that of a four Evangelists symbols page and yet

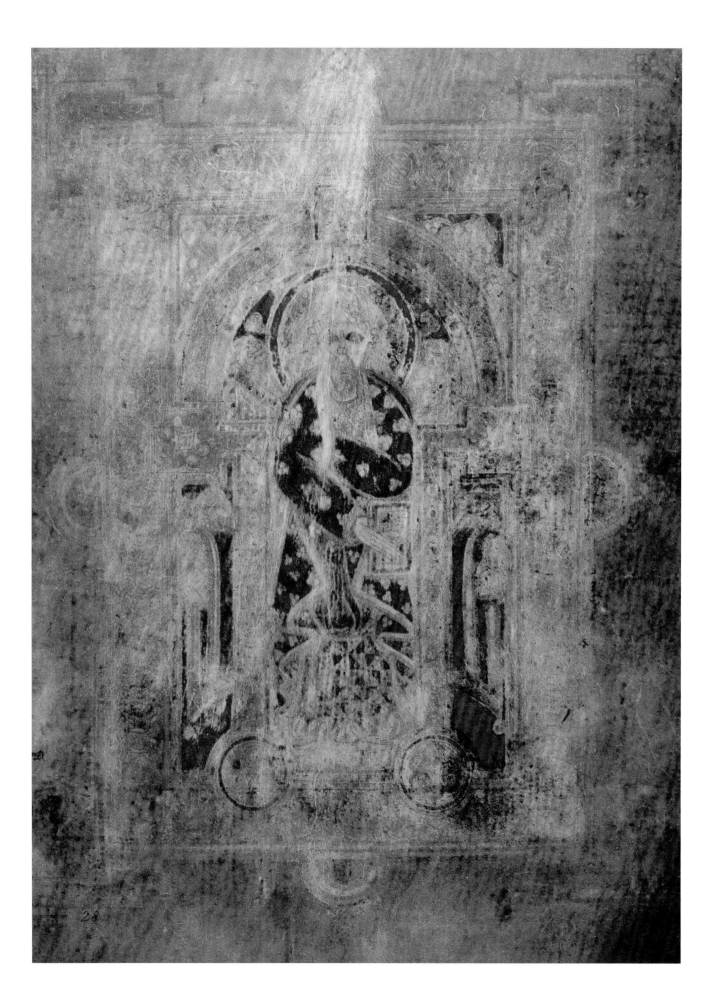

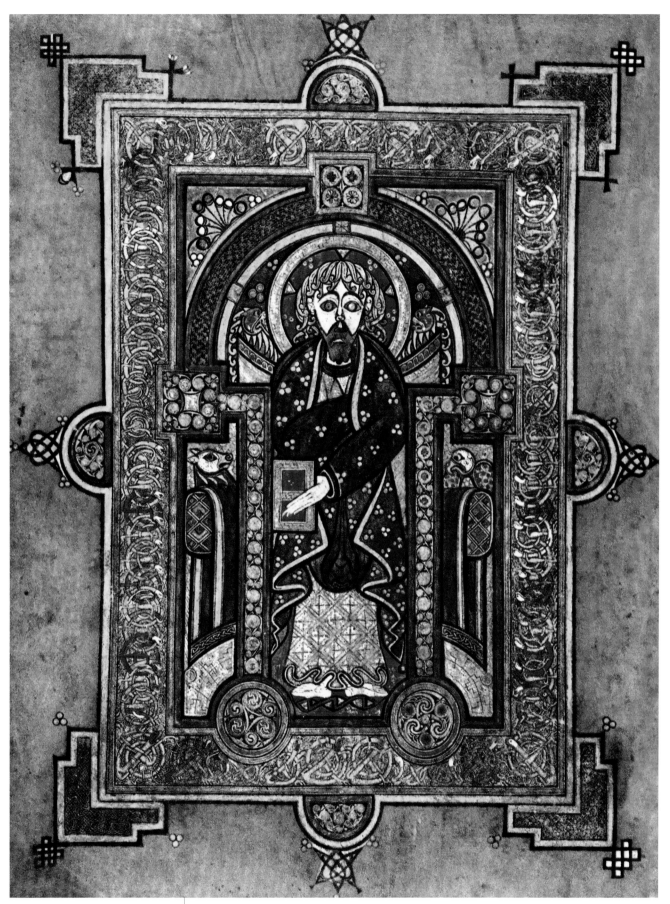

ff.28r–28v. Folio 28r was originally left blank. It is a good example of how artwork on a folio's obverse could bleed through. Its ghostly image is from f28v, the Portrait of Matthew. ©VISIPIX.COM

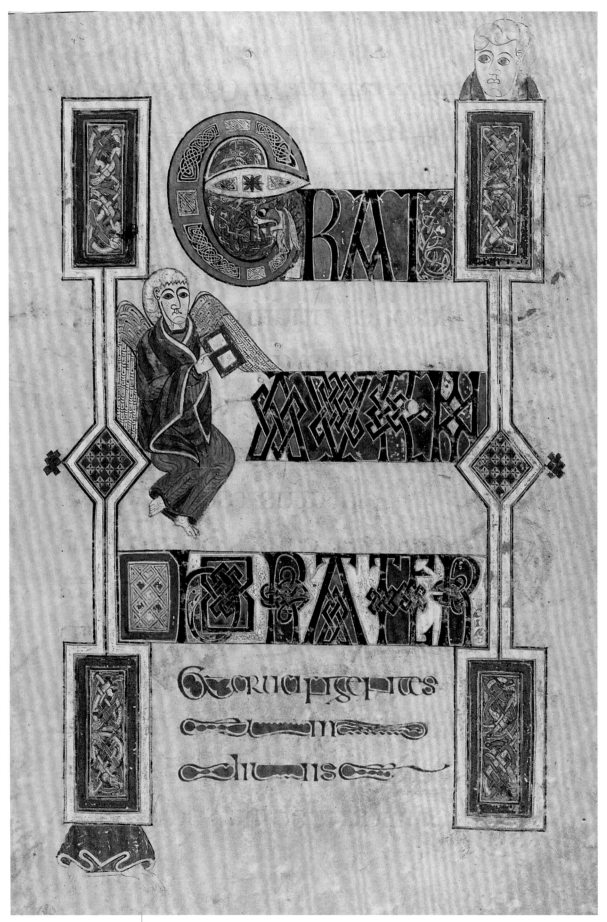

f.183r. The Crucifixion. This ornamental text page contains the opening words from Mark 15:24 Erat autem hora tercia. *("Now it was the third hour.")* ©VISIPIX.COM

its actual function seems to be that of an ornamented text page. It is even possible that it was ultimately intended to be a full-page illustration depicting the Ascension. However, judging from its relatively spare frame and dearth of decoration, it seems to have never been completed.

The Gospel of Luke (ff.188r–290r) begins with an Introductory page (f.188r) but is missing the Evangelist portrait and the four Evangelists symbols pages. Luke's Introductory page does not contain his symbolic image. Embedded in its ornamented text are the letters spelling out the Gospel's opening word : *Quoniam* ("Forasmuch"). This opening passage, which continues on to the verso page (188v) and ends with Luke 1:4, is the Evangelist's prefatory remarks explaining his purpose in telling the story of Christ's mission. The actual story commences on folio 188v with a highly elaborate letter F, formed out of a calf with an elongated body intertwined with vines and a fish, and begins Luke 1:5 *Fuit in diebus Herodias* ("There was in the days of Herod").

The next full page presentations form an interesting pairing of an illustration depicting the Temptation (f.202v) and a page of ornamented text (f.203r) in which are embedded the words from Luke 4:1 *IHS autem plenums SB (Spiritu) SSCO (Sancto)* ("Now Jesus, full of the Holy Spirit"). The Temptation illustration features Christ atop the Temple with a dark, reedy representation of Satan to His lower left. Further down is a figure in a doorway beneath which is a crowd of people. In so far as the Temptation story, whose opening lines appear on the facing page, segues into the story of Christ's preaching among the communities around Galilee it has been suggested that this second figure is Christ Himself and that the crowd below represent those communities.

The last full-page representation in the Gospel of Luke is a page of ornamented text heralding the Resurrection story with the opening words from Luke 24:1: *Una autem sabbati ualde de lu[culo]* ("But on this first day of the week") (f.285r). As we have seen in the instance of a possibly missing illustration of the Crucifixion in the Gospel of Matthew, so in Luke, a page has been left blank (f.289v). That this page, the Gospels last, would have ended the Resurrection story has suggested to scholars that an illustration depicting the Ascension was intended for this page but never executed.

The Gospel of John (ff.290v–339v) has a four Evangelists symbols page (f.290v), a portrait of the Evangelist (f.291v), and an Introductory page (f.292r). Also, as we have seen in Matthew, there is a blank page (f.291r) on which the image of the Evangelist portrait (f.291v) has bled through.

John's four symbols page stands in contrast to those in Matthew (f.27v) and Mark (f.129v). There the Evangelists hover in rectangular spaces created by what can be seen as a large representation of the Cross. In John, the Evangelists are presented within the frame of a saltier design, a presentation that recalls the Ascension story page in Mark (f.187v). On deeper analysis, this particular shape suggests the positioning of arms in what is known as the "Osiris pose." Note the symbol of Matthew's crossed arms in the top space. This "Osiris pose" is thematically significant in the *Book of Kells* and will be discussed later.

On the Portrait page, John is pointedly shown holding up a book. Although in various instances in the manuscript all of the Evangelists are shown with a book in hand, the image here is particularly significant insofar as the central theme in

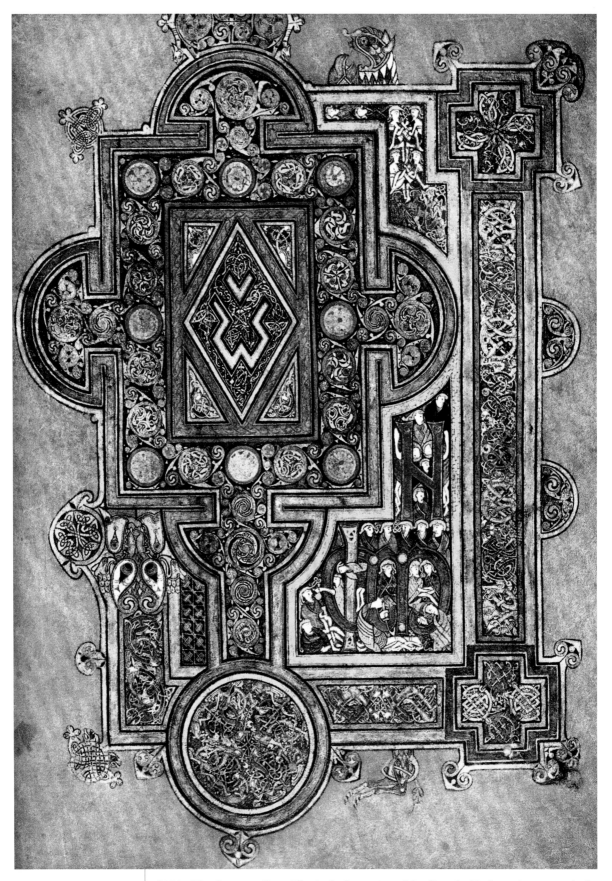

f.188r. The Quoniam Page. This is the beginning of the Gospel of Luke and contains the letters spelling the word Quoniam *("Forasmuch"). On the folio's obverse is the continuation of Luke 1:1–4 . The Evangelist's symbol does not appear on this page. Note the head of the strange beast at the top of the frame and its hind legs dangling from the frame's bottom. This may possibly be a "Godhead" symbol. Facing is the same page from the* Lindisfarne Gospels. ©VISIPIX.COM

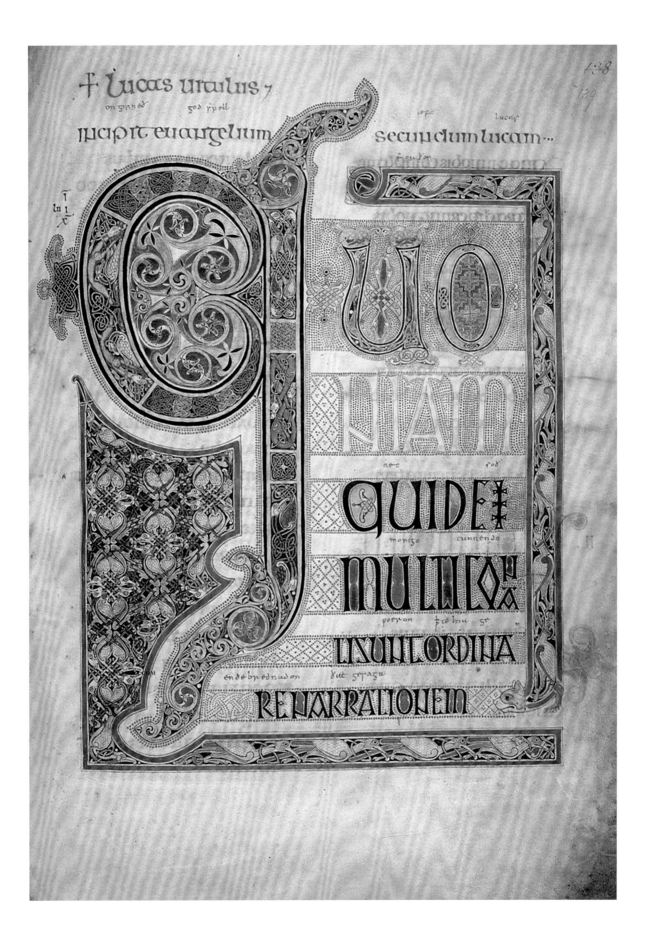

THE BOOK OF KELLS | 25

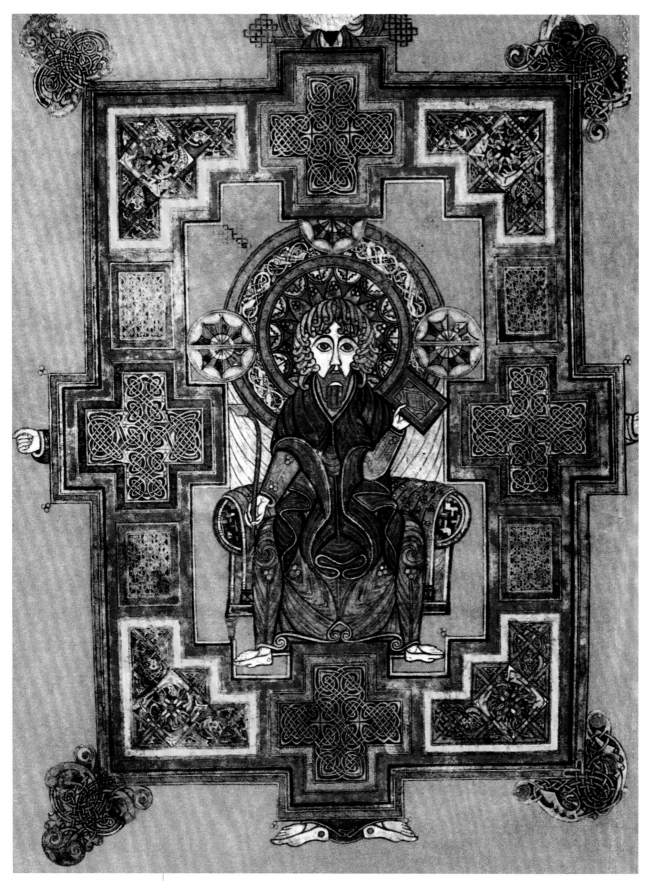

f.291v. The Portrait of John. The upper edge of this page was cut off during a poorly executed rebinding in the eighteenth century. However, the bearded jaw of a mysterious figure can still be seen at the top of the frame. Its hands stick out from the frame's sides and its feet from the frame's bottom. Though truncated, this may be the manuscript's clearest depiction of the "Godhead" symbol. ©VISIPIX.COM

the beginning of John's Gospel is the Word. The image of a book is not only one of John's signature symbols but is also a reminder of this grander theme, not only here but also elsewhere in the manuscript. This notion is again reflected on the Introductory page in whose decorative text are embedded his Gospel's opening words *In principio erat Verbum et Verbum* ("In the beginning was the Word and the Word…"). The text is adorned with two human figures, both of which could be representations of the Evangelist. However, scholars have suggested that only the smaller figure, shown in profile on the page's upper right-hand corner, is John, while the larger figure facing the viewer and holding a book is an anthropomorphic icon representing the Word. A more comprehensive analysis of this theme as it appears throughout the *Book of Kells* will be discussed later in this survey.

After the Introductory page there are no other full-page illuminations. This is most certainly due to the fact that the pages relating the Passion and Ascension stories were lost during the manuscript's theft. It is believed that within those missing folios were illustrations of the Crucifixion and the Resurrection.

Scribes, Painters, and Tools

The *Book of Kells* would have been created in a facility in the monastery known as the scriptorium (a place for writing). Between the sixth and ninth centuries, insular monasteries and those on the Continent that were wealthy enough would have had libraries stocked with indigenous works and classical Latin texts. The monastery's monks, some of whom functioned as scribes while others as artists, executed the translation, transcription, and illumination of these works in the scriptorium. Columban monasteries were believed to have been relatively well off financially, especially those at Iona and Kells, and so they would have had such facilities as well as a sufficient number a monks to adequately handle projects as complex and time-consuming as the creation of illuminated manuscripts. These projects were communal efforts overseen by a senior monk or an *armarius* (provisioner). Judging from the numerous inconsistencies in the production of the *Book of Kells*, such as the disordered sequence in the *Breves causae* and *Argumentum*, the conflation of indexes in the Canon Tables, the missing and possibly unfinished illustrations, and the almost casual disregard in the use of Vulgate and Old Latin translations, the supervision at Kells appears to have been fairly lax. The scribes undoubtedly worked in an atmosphere that allowed a considerable amount of artistic license.

However, as a general rule, the painters worked with the scribes to create continuity between the textual content and artwork relevant to that content. We have already seen this dynamic at work with the pairing of the Virgin and Child illustration (f.7v) and the beginning of the *Breves causae* of Matthew (f.8r) as well as with the segue from the Temptation illustration (f.202v) and the facing page's ornamented text that continues that story in the Gospel of Luke (f.203r). There are instances, however, when this creative dialog seems to have broken down. As previously noted, one example of this is the apparently unfinished pairing of the decorated text relating the Crucifixion in the Gospel of Matthew (f.124r) and the blank page opposite (f.123v), which was presumably meant for a full page illustration of the Crucifixion. The scribe and painter worked hand-in-glove on

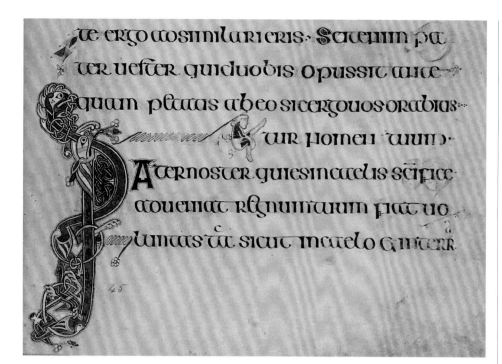

f.45r. Detail. ©VISIPIX.COM

the decorated text page but the painter, or painters, never finished the project by providing a full-page illustration on the facing page. A less dramatic example of unfinished artwork appears in the Genealogy in the Gospel of Matthew (f.30v and 31r) where the spare ornamentation suggests a lack of follow-up. Here the scribe has added to his text outlines of shapes that one assumes were to be embellished by an artist, but never were.

In another area where the painters would follow the scribes' direction, the latter would often leave spaces at the first line of particular passage's text to which the painter would then add a decorated initial, name, word, or series of words. Decorated initials appear on almost every page of the manuscript's text. A fine example of a dramatically elaborate single initial can be seen in the Gospel of Matthew at 6:9 (f.45r) which is the beginning of Christ's instructions on how to pray. The verse "Our Father who art in Heaven" commences with the Latin word *Paternoster* whose elongated letter *P* has been formed out of intertwined lions. In the Gospel of Luke we find a comprehensive example of decorated initials and words on the page which begins the Genealogy of Luke 3:23 (f.200r). Each name in the genealogy's list is preceded by the Latin phrase *QUI FUIT* (Who was), with the letter *Q* in the word *QUI* being rendered in a highly ornate fashion and the letters U and I in a somewhat more sedate presentation. This vertical word pattern continues for the entire genealogy (ff.200v–202r) with the letter *Q* morphing into a variety of ornamented styles.

A good example of what are known as "compound initials" appears on the page of text which is the beginning of Mark 13:17–22 (f.104r). The first line begins with the Latin words *Vae autem*. Here the letters *V* and *a* form a composite letter. The next full line begins with *Orate autem*. Here the trapezoidal letter *O* forms a composite with the letter *r*. The third line begins *Erit enim* with the *E* and *r* in composite form. Next are the words *Et nisi*, the *E* and *t* as composite. The fifth full line begins with *Tunc si*, the *T* and *u* as composite and the last line begins with the word *Surgent* with *S* and *u* combined. It is admittedly not easy to make out

VI · fuit · naason
VI · fuit · aminadab
VI · fuit · aram
VI · fuit · asron
VI · fuit · fares
VI · fuit · iudae
VI · fuit · iacob
VI · fuit · isaac
VI · fuit · abraeham
VI · fuit · tharae
VI · fuit · nachor
VI · fuit · scruch
VI · fuit · ragau
VI · fuit · faleg
VI · fuit · eber
VI · fuit · sala
VI · fuit · cana

f.201v. Luke 3:32–3:36 A page from the Genealogy from the Gospel of Luke. ©VISIPIX.COM

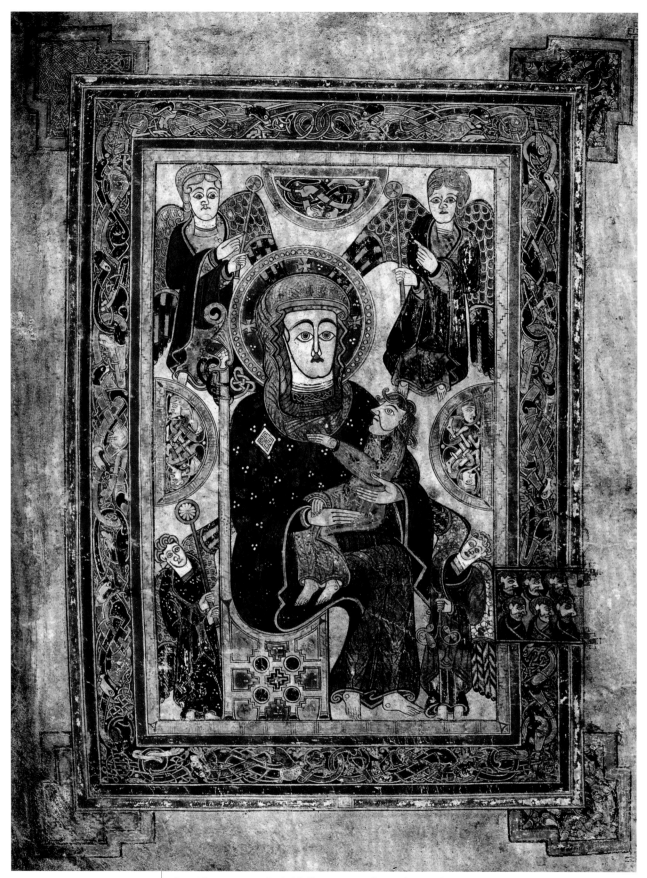

f.7v. The Virgin and Child Illustration. This is the first known representation of the Virgin and Child in a Western manuscript. Note the flabella and flowering boughs wielded by the four angels who may be the archangels Michael, Gabriel, Raphael, and Uriel. The illustration also contains a group of figures on the lower right of the frame that seem to be encouraging the reader to continue on to the opposite page, the story of Christ's birth. ©VISIPIX.COM

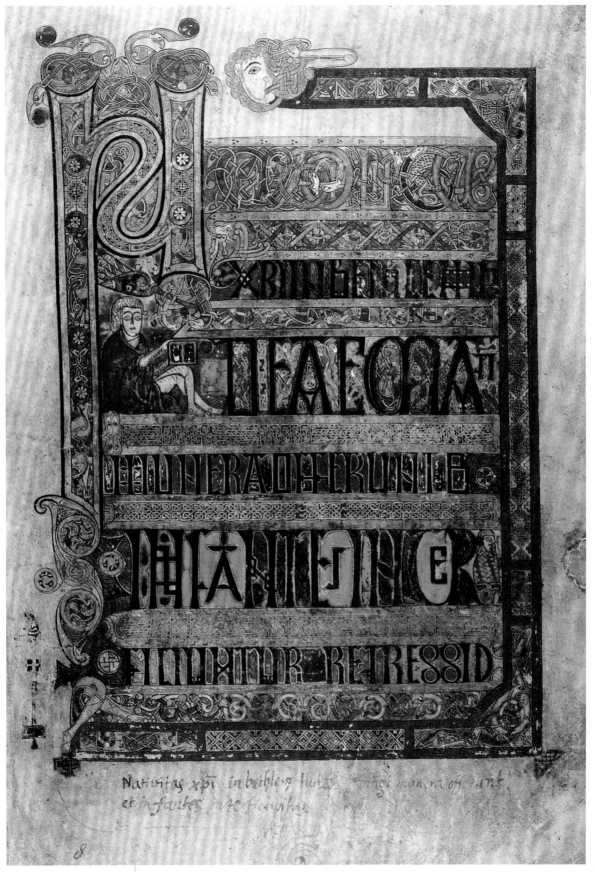

f.8r. Beginning of the Breves causae *of Matthew. This ornamental text page presents the words* Nativitas XPI (Christi) in Bethlehem Judaea. Magi munera offerunt et infantes interficiuntur. Regressio. (*The birth of Christ at Bethlehem; the Magi; the Massacre of the Innocents; the return.) As the beginning of the story of Christ's birth and its immediate aftermath, this is the subject matter that the Virgin and Child illustration serves to introduce.* ©VISIPIX.COM

these highly ornate letters but the more time one spends perusing the manuscript, the easier it becomes to identify them.

Another method with which the painters followed the scribes' direction in maintaining continuity between the text and the decoration is the use of what can be called "pointing devices." These are various kinds of images that appear on the full-page illuminations or within the text. In the former case, their purpose is to direct the viewer's attention to the text of a page opposite or the continuation of the text whose content continues or expands upon that of the full-page illumination. One such "pointing device" appears on the Virgin and Child page (f.7v). Towards the bottom of the picture's right frame is a rectangle containing six figures, all of whom are looking at the opposite page (f.8r). This is the decorated text page that begins the *Breves causae* of Matthew with *Nativitas XPI in Bethlehem* ("The birth of Christ in Bethlehem"). That the rectangle with figures breaks

the picture's frame in a rather obtrusive way, looking as if it was superimposed as an afterthought, lends credence to seeing this image as a "pointing device" which was added to encourage the viewer to pay attention to the upcoming text in the Gospel of Matthew, which tells the full story of Christ's birth, beginning with His human genealogy.

A similar use of the "pointing device" appears on the decorated text page in Matthew containing the words *Tunc crucifixerant XPI cum eo duos latrones* ("Then were there two thieves crucified with Him") (f.124r). Here we see three rectangles; within each are five figures all of whom are looking towards the opposite page (f.123v). Unfortunately, what they are looking at is one of the manuscript's blank pages. This is the page, previously referred to, which may have been set aside for a Crucifixion illustration, one that was never done. In theory we have here the "pointing device" technique, which is the reverse of what we saw on the Virgin and Child page. Here images on the decorated text page would have been encouraging us to pay attention to the full-page illustration.

There is one more example of this technique of referring to a page opposite, albeit perhaps a little more obliquely. On the Temptation illustration page (f.202v) is a crowd to the left of Christ. In so far as there were no crowds who witnessed Christ's confrontation with Satan why has the painter added them to this page? Could it be that they are directing the viewer's attention to the facing page (f.203r), which follows His rebuking of Satan's temptations and begins the story of His preaching? This preaching was emblematic of His victory over Satan, and so the crowd to his left may very well have been a "pointing device" directing the viewer towards the story of the fruits of that victory.

There is also an instance of images being used to point the viewer not to a page opposite but to a page that continues a particular story. We see this on the decorated text page in Luke which begins with *Una autem sabbati ualde de lu*[*culo*] ("But on the first day of the week") (f.285r). This is the beginning of the Ascension story that continues on folio 285v. All four of the decorated text's angels as well as the curious beast on the upper right frame are facing towards the right hand side of the page as if to say, "turn the page and keep reading."

All of the above "pointing device" images serve a serious, almost didactic purpose. They are figurative instructions alerting the viewer as to what passages or events in the Gospels are of particular importance. But there is a carnival of far more seemingly whimsical images, which scamper in and around the manuscript's text whose function is, in most instances, jovially editorial. Cats, mice, lions, hens, and high-kicking men serve to correct transcribing errors, telling us when to keep reading or when to stop. Occasionally there appear cartoonish figures who may have been created to alleviate the painter's temporary boredom after long hours in a cold scriptorium. When a scribe left words out of a passage or misspelled words, the painter would correct the error by use of what is called a "turn-in-the-path." This was often a feline figure whose paws and body position would tell the reader where the corrected text or a missing letter from a word should be placed. The acrobatic felines on folios 51v, 71v, and 145v are good examples of this turn-in-the path function. Hens seem to be the painters' choice for indicating an emphatic period at the conclusion of a line. They can be seated or standing but in all cases are facing the last word of a sentence, implacably, as if to

tell the viewer to pay particular attention the content of the preceding line. Folios 55v, 124v, and 186r feature these hens. Another end of line, "pay attention" image features feline or cat and mouse tail-pulling. One such image appears on folio 48r. There are also "crossing guard" images whose bodies suggest that the reader stop and pay attention, but whose heads indicate that after stopping the reader should then proceed to the next pertinent passage. Folio 278r has two such images. Then there are the figures that tell you to keep reading, or "don't stop, there's more." Two such very inventive images appear on the pages of the genealogy in Luke. At the end of the last line on the genealogy's first page (f.200r) there is a figure that has been interpreted as an Irish warrior, his stance and spear clearly indicating movement towards the next page and the continuation of the genealogy's names. On the second to last page (f.201v) there is a winged calf whose fore-hooves and posture suggest that it is about to leap up to the top of the next page. Many of these interlinear images have there own symbolic meanings, which complement the text's content. For example, hens, like other birds in the manuscript, are often symbols of Resurrection and will appear in relation to passages which are related to Christ's Resurrection story. The winged calf on Luke's genealogy page mentioned above is obviously a reference to the Evangelist himself. However, many of these images are simply products of the artists' rich imaginations and have no discernable meaning other than adding emphasis to a particular passage by engaging the reader's participation in an almost interactive fashion.

As the work on the *Book of Kells* may have taken place over a long period of time and possibly at two different monasteries, Iona and Kells, it is hard to say how many scribes and painters collaborated on the book. However, scholars have identified three recurrent styles in the book's script, which suggests that there were most likely three main scribes. These have been designated as Hand A, Hand B, and Hand C.

Hand A is believed to have been the scribe who wrote the text found in the List of Hebrew names (f.1r), the *Breves causae* and *Argumentum* sections beginning with Matthew's *Breves causae* (f.8v) up to and including that of Luke (f.19v), the later text in the Gospel of Luke (ff.276–288v) and in the last half of the Gospel of John (ff.307-339). The majority of his script was written in majuscule, most of which was rendered in a brown gall ink. It is believed that Hand A was one of the manuscript's original scribes.

Hand B has been identified with the end of the *Breves causae* of Luke through the *Breves causae* of John (ff.20r–25v), the later text of the Gospel of Matthew (from approximately ff.118r–129r) and the beginning of the Gospel of Mark (ff.130v–150). He employs miniscule script more often than Hand A and makes liberal use of purple, red, and black inks.

Hand C is believed to be the manuscript's most prolific contributor. His writing has been identified with nearly all the text in the Gospel of Matthew (ff.30–117), the Gospels of Mark and Luke (ff.151–275), and the Gospel of John (ff.293–306). He used a mix of majuscule and miniscule scripts and like Hand A, employed a brown gall ink.

The artwork in the *Book of Kells* was a communal effort that enlisted the talents of not only the monks whose sole purpose was to function as painters but also those of the scribes themselves who would occasionally add decorated initials or other

embellishments on their own. But as a general rule this was the painters function. As noted previously, they would work in tandem with the scribes following their directions as to where a particular embellishment or full-page illumination should be placed. It is unknown how many painters were involved in the manuscript s production. The sheer number and varied styles of decorated initials in the text, interlinear embellishments, and iconographic symbols and images on the full-page illuminations suggests that there were several. However, through a close analysis of recurrent styles of painting, especially those used in the creation of the full page illuminations, Françoise Henry, one of the world s leading authorities on the Insular Manuscripts, has suggested in her seminal study of the *Book of Kells* that there are three main painters.

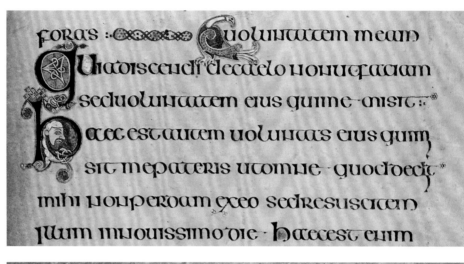

ff. 309r, 20v, 217v. Details of three hands (from top to bottom: Hand A, Hand B, Hand C). ©VISIPIX.COM

Henry has dubbed one of these painters the "Goldsmith," who she believes is responsible for the Introductory pages in the Gospels of Matthew, Mark and John (ff.29r, 130r, 292r), the Carpet page (f.33r), the Monogram (Chi-Rho) page (f.34r) and, possibly, the images in and surrounding the tympanum of the Canon Table that shows the lists for tables VI, VII, VIII (f.5r). She bases her assumption on the fact that on each of these illuminations appears the Goldsmith's signature use of metallic golden yellow and silvery blue paints and his penchant for creating intricate and sharply defined images. The Goldsmith also displays a stylistic idiosyncrasy in his use of snake/serpent imagery, particularly prevalent in the subtle profusion of spirals on the Monogram page (f.34r), and the more easily identifiable use of this motif in the formation of the letters "ER" of the word *LIBER* in the middle of Matthew's Introductory page (f.29r).

The second painter is referred to as the "Illustrator." According to Henry, it was his hand that created the Arrest and the Temptation illustrations (ff.114r, 202v). And, significantly, he was the artist who painted the Virgin and Child (f.7v), which, as mentioned above, was the first such representation in the history of Western manuscripts. He may also have painted the unique saltier framed four Evangelist symbols page in the Gospel of John (f.290v) and was perhaps a collaborator on the *Nativitas* page that begins the *Breves causae* of Matthew (f.8r). His work can be identified by the starkness of his Coptic-like figurative representations and his bold use of purple and green paints and washes. His use of intricate embellishment is far more sedate than that of the Goldsmith, which a comparison of his Arrest illustration (f.114r) and the latter's Monogram page (f.34r) makes quite clear.

Henry's third main artist is the "Portrait Painter." His use of massive framing and subtle brown and reddish-brown paint clearly differentiates his works from that of the Illustrator. These qualities are apparent in the pages that Henry assigns to him, the portraits of Matthew and of John as well as the painting for which he was probably responsible, the four Evangelists symbols page in the Gospel of Matthew.

It is interesting to note that the artist who painted the portrait of Christ remains in question. The work certainly contains elements that one would associate with the Portrait Painter. It may have been a collaborative effort. Additionally, whether it even *is* a representation of Christ was for a long time debated by scholars studying the manuscript. Like many present-day specialists in the *Book of Kells*, Henry believed that it is. However, Sir Edward Sullivan, another of the twentieth century's most respected *Book of Kells* scholars, believed that it is not Christ, but a portrait of either Luke or John erroneously placed in the Gospel of Matthew. (This would explain the whereabouts of one of the "missing portraits.") Because of this, the work has been referred to as the "Doubtful Portrait".

In the final analysis, the question of who the painters of the *Book of Kells* were is complicated by the fact that the full-page illuminations were rendered on single folios. This made a particular page easy to extract from the manuscript and so readily accessible to the ministrations of any number of the scriptorium's artists, who may have passed it among themselves, each adding his own artistic touches.

One of the attributes that make the *Book of Kells* stand out from the Insular Manuscript collection is its bold use of color and color washes. Its basic colors, white, red, yellow, blue, green, purple, black, and brown were mixed to create a

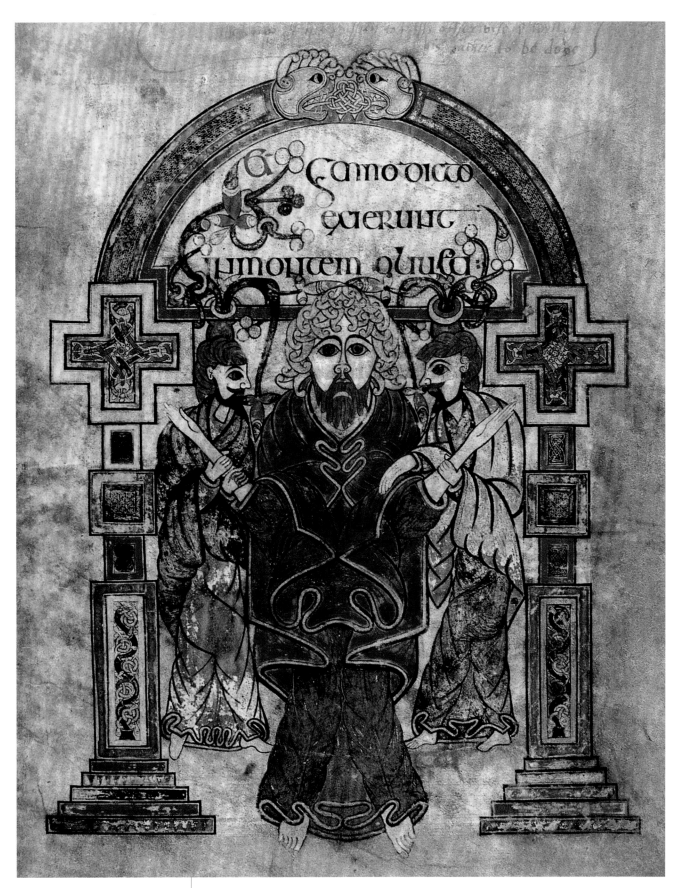

f.114r. The Arrest Illustration. This illustration begins the Crucifixion story after the Last Supper and features the text from Matthew 26:30: Et omno dicto exierunt in montem Oliveti ("And after reciting a hymn, they went out to the Mount of Olives") in the tympanum above Christ. That Christ is represented as so much larger than the soldiers arresting him shows His ultimate triumph. It was a common motif in the depiction of the Arrest in Insular Manuscripts. ©VISIPIX.COM

remarkable array of hues. The pigments were mixed with water and vinegar to which was added the binding medium of egg white or glue. It was the vinegar that caused images on one side of a folio to bleed through its blank reverse. The pigments used to create the manuscript's colors were extracted from a number of sources.

The color white came from the mineral gypsum (calcium sulfate) and from white lead (lead carbonate). As a pigment its most prominent use in the manuscript was its application as a thick coating over the bare vellum pages.

Red was derived from minium, a red lead oxide, and from kermes, a substance derived from the dried bodies of an insect of the same name. As a color motif, red or a variant of red seems to have been the choice of color for books with the figurative representations of the Evangelists and Christ. The portraits of Matthew and of Christ (ff.28v, 26v) and Matthew's Introductory page (f.29r) are examples in which this color is prominently displayed.

Yellow was obtained from an arsenic sulphide compound known as orpiment. Used widely in mediaeval manuscripts and known as *auripigmentum* ("gold color"), it served as an economical substitute for gold. It is used in the *Book of Kells* frequently and to dazzling effect, especially in architectural frames and borders whose aggressive renderings create an almost holographic depth, as can be seen on the Carpet page (f.33r) and the portrait of Christ (f.32v), and in the efflorescent embellishments of the Monogram page (f.34r). It is also employed extensively in the text's ornamental lettering.

Blue was derived from plant extracts folium, indigo and woad. Some scholars believe that ultramarine, a derivative of *lapis lazuli*, was also used. Others doubt that, citing its high cost and rarity. Blue and a bluish-green variant often serve to dramatize the garments of the manuscript's figurative representations, as with the Arrest illustration (f.114r) or on the bodies of the zoomorphic symbols of the Evangelists on the four symbols pages of Matthew (f.27v) and Mark (f.129v). The contrast between the decorated text pages in Mark and Luke (ff.183r, 285r) provides a good example of the range of this color's effects. Its use in creating decisive borders and frames is in evidence on a decorated text page in Matthew (f.124r), on Mark's Introductory page (f.130r), on the Temptation illustration in Luke (f.202v) and, in John, the Portrait page and the Introductory page (ff.291v, 292r). Like yellow, blue is found throughout the text's ornamental lettering.

Green, featured prominently in the Temptation illustration (f.202v), had two sources. One was verdigris, a copper acetate residue. The other was a combination of colors, orpiment and blue (from indigo or woad), which is referred to as vergaut. Ox gall, a green or greenish yellow fluid extracted from the bladders of oxen was another source of green (and yellow) pigments.

Purple, commonly used to color the robes worn by figurative representations, as in the Virgin and Child, Arrest, and portrait of Christ pages (ff.7v, 32v, 114r) was derived from a variant of vergaut in which blue was the prominent color in the admixture.

The manuscript's deepest color, black, was an extract of the chemical compound "amorphous carbon," derived from the residue of charred bone or wood. Known as "carbon black," it was used by the scribe "Hand B" in some of his text lines. Elsewhere it was used sparingly on the full-page illuminations but extensively in ornamental lettering and embellished initials throughout the text. Examples of its use in

ornamental text lettering appear at the beginning of the *Argumenta* of Matthew and John (ff.12r, 18r) and on decorated text pages in Matthew (ff.114v, 124r).

The ink used to transcribe the manuscript's text was, on most pages, a brownish iron gall ink. A standard medium in the Insular Manuscripts, the ink was a preparation made from the iron salts and tannic acids extracted from oak "galls." These are round growths and protuberances found on oak trees; they are created by nesting insects, usually a species of wasp. In addition to the color brown, iron gall ink could be produced in black and in purple.

As for the implements used, the scribes would have wielded pens made from the quills of geese, swans, and crows. The painters would have used these quills and perhaps styluses to effect outlines for their images adding paints and washes with fine pointed brushes possibly made of marten fur. Both would have been used with wooden straightedges and metal compasses and curves.

Symbols, Iconography and Themes
IMAGES AND SYMBOLS OF THE EVANGELISTS

The manuscript's most common figurative images are those of the Evangelists. Appearing on almost every full-page illumination, each Evangelist has his own signature representation. These representations are not unique to the *Book of Kells* but grew out of long established traditions in Christian iconography and symbolism.

The Evangelists' images are, in part, based on the introductory verses in each Gospel. Matthew is portrayed as a human figure because his Gospel commences with the recounting of Christ's genealogy, a human ancestry beginning with Abraham (Matthew 1:1–17). Mark's representation is that of a lion, the king of wild beasts, the imagery of which is suggested in his opening quote from Isaiah proclaiming the coming of a "messenger" (John the Baptist), "the voice of one crying in the wilderness" (Mark 1:1–8). Luke's figurative representation is the calf, a sacrificial symbol which recalls his Gospel's opening story of Zechariah and his ritual sacrifice at the behest of the angel Gabriel (Luke 1:5–25). John's Gospel begins: "In the beginning was the Word, and the Word was with God and the Word was God…" His symbol is the eagle, which is a figurative representation of the "soaring" poetry of these opening lines.

Another source of the Evangelists' images is the relation each has to the life of Christ. Matthew's human image represents Christ's birth as the Son of Man. Luke, as the sacrificial calf, is a visual metaphor for His death. Mark, as the all-powerful lion, suggests Christ's Resurrection. And John, the eagle who soars into the heavens, proclaims the glory of His Ascension.

With the origin and nature of these images in mind, it becomes relatively easy to identify each Evangelist in the manuscript's four Evangelist symbols pages. In Matthew's (f.27v), we see his image in the upper left rectangle, and then, clockwise, those of Mark, John, and Luke. We have the same sequence on Mark's symbols page (f.129v) and a slightly altered presentation in John (f.290v), with Matthew at the top and, again clockwise, the images of John, Luke, and Mark. It is important to point out the winged zoomorphic images of Mark and Luke (ff. 27v, 129v and 290v). This kind of composite representation of the Evangelists appears elsewhere and is a symbolically significant leitmotif, the possible mean-

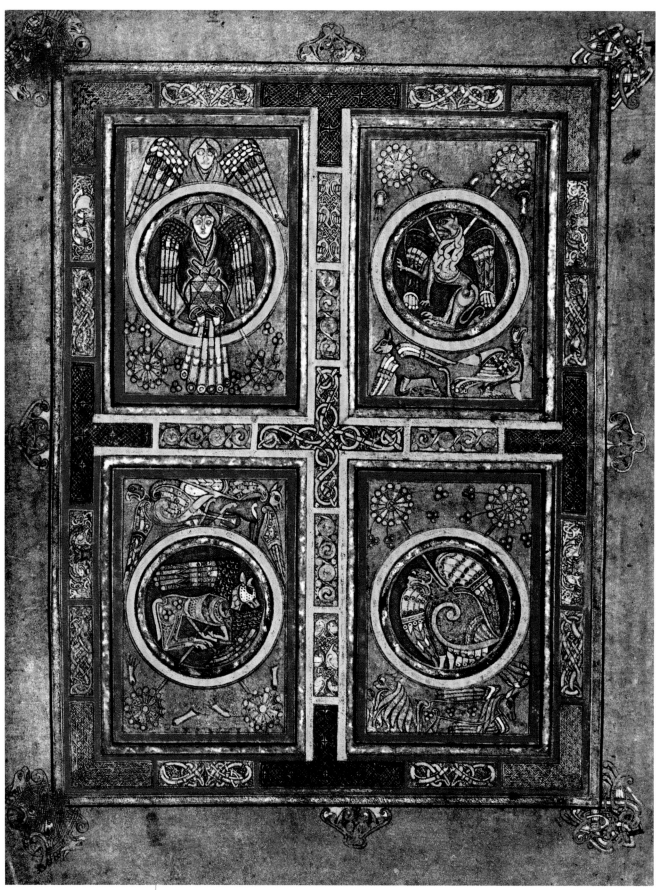

f.129v. The Four Evangelists Symbols page in the Gospel of Mark. Note the unique presentation for each Evangelist. Matthew's symbol seems to appear twice. Beneath Mark's are the symbols for Luke (calf) and John (eagle) and similarly, under John's are the symbols for Mark (lion) and Luke and above Luke's are the symbols for John and Mark. ©VISIPIX.COM

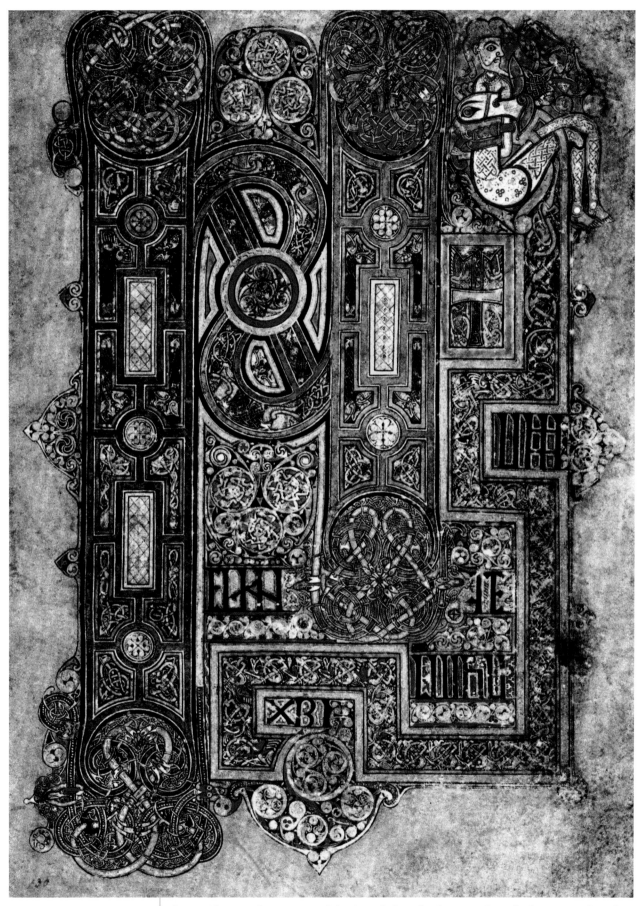

f.130r. The Introductory Page of the Gospel of Mark. The text is from the beginning of Mark: Initium evangelii Ihu XPI (*"The Beginning of the Gospel of Jesus Christ"). On the upper right of this illumination we see a uniquely composite image of Mark, a serpent and a lion.* ©VISIPIX.COM

ing of which will be addressed at the end of this section. The symbolic images of Mark, Luke, and John are also easily identifiable on the portrait of Matthew (f. 28v) with two lions' heads at Matthew's shoulders, the head of a calf, left-center, and that of an eagle, right-center.

Identifying the Evangelist images on the Gospels' Introductory pages can be trickier. The problem on Matthew's Introductory page (f.29r) is that there are three figures present. Scholars disagree on the identity of the larger figure on the lower left. Some think it is Matthew while others suggest it is someone associated with the production of the manuscript but not a participant in its creation, perhaps a patron. Directly above is a small faceless winged figure, which could be an unfinished representation of the Evangelist or perhaps an angel. Most agree that the image atop the page is indeed Matthew. The image on the upper right corner of Mark's introductory page (f.130r) presents a more complicated issue of interpretation. It is a human head with an elongated body that seems to be in the jaws of a beast and is entangled with a red serpent and the tail feathers of two peacocks. Leaving aside the symbolism of the peacocks for now, the image has been identified as a miniature portrait of Mark in profile assisted in his struggle with the serpent (Satan) by his own symbolic representation, the lion. However, due to the multifarious aspects of the serpent in Christian symbolism, this interpretation remains open to question and will be discussed more fully below. In any case, this image of Mark is an intriguing composite. A similar problem occurs on John's Introductory page (f. 292r) where anthropomorphic images are substituted for the Evangelists zoomorphic symbol. But here, unlike the presence of a lion on Mark's page, there is no hint of the presence John's symbol, the eagle. The smaller figure holding a reddish chalice on the upper right of the page is believed to be the Evangelist while the larger figure holding a book at the top of the page could serve a dual purpose as a miniature portrait of the Evangelist and as an anthropomorphic representation of the central theme of his Gospel, the Word. Luke's Introductory page, as noted above in our discussion of the Gospel of Luke, has no representation of the Evangelist, neither his symbol, the calf, nor an anthropomorphic image.

The Canon Tables are replete with symbols of the Evangelists. Their images on the previously noted List of Hebrew names (f.1r) are quite difficult to make out due to that folio's worn condition, but those in the arched tympanums atop the architectural columns are readily identifiable. Canon Table I (ff.1v, 2r) is a cross-referenced index for all four Evangelists, who appear in proper order (Matthew, Mark, Luke, John) from left to right. Canon Table II (ff.2v, 3r, 3v) features the indexes of Matthew, Mark, and Luke, who are displayed appropriately enough in the tympanums of all three folios. However, as noted above in the general introduction to the Canon Tables, the last folio (3v) contains the text of references pertaining to Matthew, Mark, and Luke but also presents a compressed index for what should be Canon Table III, which references Matthew, Luke, and John. Ideally, Canon Table III should have been on a separate folio page featuring in its tympanum the symbols for those latter three Evangelists. Another oddity in the Canon Table II series is the presence of what appears to be an unnecessary symbol of Matthew in a disk directly below the tympanum of the table's second page (f. 3r). Canon Table IV (Matthew, Mark, John) is noteworthy for its unique representations of the Evan-

gelists. Here the images seem rather whimsical, lacking the *gravitas* displayed in the other Canon Tables and possessing an almost cartoonish quality, especially the depiction of Mark's lion. Also, relatively spare in its embellishment, it displays only the names of the table's Evangelists where complex interlacing and other decoration usually appear. Canon Table V (f. 4v) appears to be unfinished and, as such, serves as another example of the laxity in the manuscript's production. There are no symbolic representations of either of the table's Evangelists, Matthew or Luke. The small area in the tympanum, which contains indecipherable writing, may have been designated originally for those images. The only reference to the Evangelists is a repetition of their names written above the table's arcade. The page opposite (f.5r), Canon Tables VI, VII and VIII, suggests what Canon Table V might have looked like had it been completed. Although this table presents cross-referenced indexes pertaining only to Mark and Luke, all four Evangelists are presented. Mark and Luke are within the tympanum while Matthew and John are perched atop the tympanum's frame. This presentation of the Evangelists in the traditional sequence of Matthew, Mark, Luke, and John seems a fitting end to the full-page illuminations in the Canon Tables.

IMAGES AND SYMBOLS OF CHRIST

Figurative images of Christ appear four times in the *Book of Kells*. They are found on the Virgin and Child page (f.7v), the Arrest illustration (f.114r), the Temptation illustration (f.202v) and, putting aside the "Doubtful Portrait" controversy, His portrait in Matthew (f.32v). Symbolic images, which represent Him or some aspect of His nature take many forms and appear on a number of illuminated pages.

Of figurative iconography related to Christ's symbols, angels, sometimes with wings and sometimes without, can serve a complementary heraldic function. This is seen on the Virgin and Child page, the Temptation illustration and the portrait of Christ. Elsewhere they act as figurative symbols of His Holy Ascension, suggesting to the manuscript's viewer His unseen but implicit presence. An angel hovers holding a book on the ornamental text page in Mark which begins the crucifixion story, *Erat autem hora tercia* ("Now it was the third hour") (f.183r). That the winged image appears to be floating may subtly prefigure Christ's forthcoming Resurrection and Ascension. Another hovering angel appears on the Gospel of Mark's Ascension page (f.187v) and is, significantly, opposite the Evangelist's lion symbol, which represents the Resurrection. Again, with no figurative image of Christ Himself present, four angels seem to herald His Ascension on the ornamental text page in the Gospel of Luke that begins with the words *Una autem sabbati ualde de lu*[*culo*] ("But on the first day of the week") (f.285r).

Another recurrent image in the manuscript symbolizing an aspect of Christ is the flabellum. Flabella were circular fans originally used in Eastern Churches to keep the altar and Eucharist clear of flies and dust. Employed as an artistic device in illuminated manuscripts it came to symbolize the purity of Christ. In addition to the image of a book, which we have seen is a symbol of the Word, flabella are often flourished by the *Book of Kells*' angels, a clear example of which appears on the Virgin and Child page (f.7v). Flabella are also spiritual accoutrements associated with Evangelists. Matthew is clearly holding a flabellum on the page

containing Canon Tables VI, VII, VII (f.5r) as well as a cruciform variant on his Evangelist symbols page (f. 27v). All the Evangelists feature flabella on Mark's Evangelist symbols page (f. 129v). Also, there is a figure in the door of the Temple on the Temptation illustration (f.202v) who holds two flabella.

Angels and Evangelists are also seen holding flowering boughs. The flower and stem was an ancient Christian motif, the flower symbolizing Christ, the stem, Mary. The source of this imagery may have come from Isaiah 11:1 "From the stock of Jesse a scion shall burgeon yet, out of his roots a flower shall spring." The angel on the lower right of the Virgin and Child page holds a flowering bough as does a similarly positioned angel on the previously referred to decorated text page in Luke (f. 285r). Note on that page the flabellum and books. There is also a curious figure behind the large M in the beginning of the *Argumentum* of Matthew who is holding two flowering boughs. On the upper left of the Monogram page, positioned horizontally, three barely discernable angels hold boughs, with two of them also brandishing books.

Images of peacocks are emblems of Christ that symbolize His eternal life. One source of this motif was the belief that the flesh of dead peacocks did not rot. Additionally, the dazzling display of color in this "deathless" creature's tail feathers serves as a visual metaphor for the unfathomable majesty of His miraculous transformation. Nowhere in the book is this symbol of eternal life more clearly represented than on the Christ Portrait page (f.32v) where we see two heraldic peacocks on either side of His head. Peacocks also appear in the aforementioned composite image of Mark on his Introductory page (f.130r). We can now see in this image the two symbols of Christ's miraculous redemption: the "man/lion" of Resurrection and the "peacock" of eternal life, as they struggle with Satan's symbol depicting the Fall, the Snake. Another significant display of peacocks occurs on the tailpiece at the bottom of the genealogy in the Gospel of Luke (f.202r). Here two intertwined elongated peacocks are set against a second image, that of a chalice from which vines are sprouting. This second image constitutes one of the most meaningful in the repertoire of Christ's symbols in the *Book of Kells*.

The chalice is a symbol of the Eucharist, the ritual by which the faithful can partake in the Body and Blood of Christ and in so doing become one with Him in eternal life. Vines are symbols of Christ's lineage as the Son of Man and so represent the deep rooted family tree that goes back to Adam. But vines are also the symbol of Christ as the paragon of the "true Israel," the one who will bring to fruition the mission mandated by the Covenant that the "old Israel" failed to complete. The source of this complex symbolic reference can be found in John 15, the chapter in which Christ describes the proper relationship that the Christian community should have with Him and with each other. The chapter begins "I am the true vine, and my Father is the vinedresser" (John 15:1). In another passage Christ declares, "I am the vine, you are the branches. He who abides in me, and I in him, he it is that bears much fruit, for apart from me you can do nothing" (John 15:5). Because the most sacred witness to this relationship is expressed in the partaking of the Eucharist, the chalice and vine are inextricably linked as one the most comprehensively meaningful symbolic motifs of Christ. Vines and chalices appear throughout the manuscript. We see this motif presented above the heads of the two figures seizing Christ on the Temptation illustration page (f.114r).

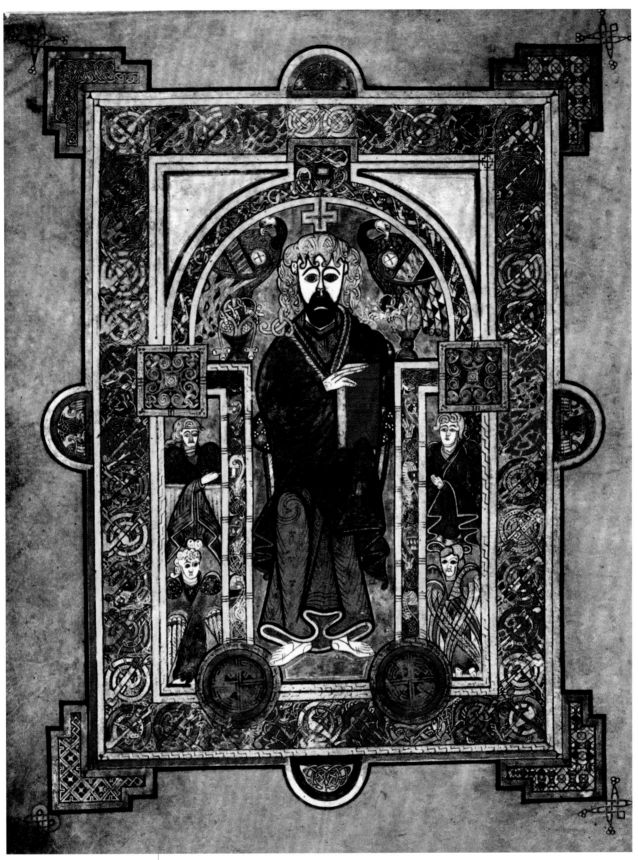

f.32v. The Portrait of Christ. The identity of this figure was long debated among the manuscript's scholars. Some believed it to be a portrait of Mark or of Luke. For this reason this portrait has been referred to as the "Doubtful Portrait." Assuming with most present day scholars that it is in fact Christ, this portrait and its attendant imagery can be seen as a representation of the Majestas Domini (Christ in Majesty), *a motif common to illuminated manuscripts beginning in the mid-fourth century.* ©VISIPIX.COM

On the Christ Portrait page (f.32v) we see the chalice/vine motif being used in a most dramatic way. The feet of the peacocks at Christ's shoulders are entangled in vines sprouting from two chalices. Here we have a composite symbol that addresses Christ's eternal life (the peacocks), His relation to the Christian community (the vines), and the transformation that occurs in partaking of the Eucharist (the chalices). As noted above, we also see the peacock/vine/chalice motif on the tailpiece of the last page of the genealogy in the Gospel of Luke (f.202r). Now, knowing the interrelated symbolic meanings of these images, we can see how fitting their composite presentation is in relation to the genealogy. Also, in relation to contextual continuity noted in the Painters and Scribes section, we see how seamless the communication between the painter and scribe could be.

Snakes appear in profusion amidst the manuscript's pages, however their detection and differentiation from vines and other foliage may require the use of a magnifying glass. As noted above, the snake can be a symbol of the Fall, or, put another way, Satan's victory. But it has another theological meaning, functioning as the symbolic image of Christ's Resurrection and as the image of His eternal life. To the pre-Christian Celts, as indeed to many other cultures worldwide, the snake's ability to shed its skin was seen as a representation of the principles of renewal and rebirth that mirrored the inexorable diurnal round, the changing seasons and the disappearance and return of heavenly bodies. Also, in pre-Christian Celtic art and in that of other world cultures, the image of the snake devouring its tail served as a symbol of eternity. In addition to seeing the snake as a symbol of the Fall, the Christian Church used these latter two motifs as representations of Christ's Resurrection and His eternal life. With this in mind, we can return to the Introductory page in the Gospel of Mark (f.130r) and reassess the meaning of the snake image in the previously discussed composite image of Mark. Is it possible that the red snake is a symbol of Resurrection and eternal life? If so the composite image of the anthropomorphic Mark, the lion and the peacocks, is not struggling with a snake symbolizing the Fall, but rather embracing the snake that symbolizes the Resurrection and life everlasting. There is still more snake imagery on this page. If interpreted as complementary to Mark's symbolic designation as the Evangelist who represents Resurrection (the Lion), this imagery could be described as representing the Resurrection and not the Fall. Snakes form a nest of spirals at the top and the bottom of the enormous letter *I* of the ornamented text's first word *INITIUM* and again at Mark's back. Further down there is a spiral of somewhat genial-looking snakes whose heads and tongues point at the Latin letters *EVAN* on the lower left and the letters *GE* on the right. These letters are part of the word *EVANGELII*, that is, "Gospel" or "good news." It seems likely that this particular juxtaposition of symbol and word on the Introductory page of a Gospel whose central theme is the "good news" of the Resurrection refers in fact to the Resurrection of Christ and not the victory of Satan.

One of the manuscript's most intriguing symbols of Christ's Resurrection, and one that also serves to represent His role as Judgment Day's final arbiter, is the presentation of images that bear a likeness to Osiris, the resurrected Egyptian god who sat in judgment of the dead. The iconic pose in which Osiris was presented in Egyptian texts holding a flail and scepter diagonally over his chest and shoulders has its analogous, if somewhat oblique representation, intermittently in the

manuscript. One example of the subtle, almost sly, reference to this pose appears in the mysterious figure atop the arcade of Canon Table IV (f.4r), who is holding two books diagonally at his shoulders. A similar pose is assumed by the figure holding two flowering boughs behind the large letter *M* that begins the Argumentum of Matthew (f.12r). The aforementioned angels on the left frame of the Monogram page (f.34r) brandish books and flabella in a similar pose, as does the figure holding flabella in the doorway of the Temple on the Temptation illustration page (f.202v). On the Arrest illustration page (f.114r) Christ's arms assume a geometric shape that could be interpreted as "Osirian", although their position can also be seen as a cruciform representation. The most obvious example of this dual symbol of Resurrection and Judgment appears on the Evangelist symbols page in the Gospel of John (f.290v). Here we see Matthew's symbol brandishing two books in the "flail and scepter" fashion. Also, this page's diagonal saltier frame can be seen as an abstract representation of this symbolic motif.

The use of the pagan iconography of the Osiris myth as a symbol of Christ by the manuscript's artists reminds us that some of the *Book of Kells'* artistic progenitors may have been of Coptic and even earlier Middle Eastern origins. A common motif in the artistic rendering of sacred subjects, especially in Hebrew, and later, Islamic, cultures, was the use of aniconic symbols. Aniconic means "without likeness" or "without image" and in the arena of religious artistic expression, it refers to the belief that any naturalistic figurative representation of God or any other sacred subject is blasphemous. This artistic motif accounts for the *Book of Kells'* Carpet page (f.33r) and, in a less rigorous fashion, the Monogram page (f.34r).

Historically, Carpet pages, so named because of their likeness to the "oriental" carpets associated with Middle Eastern cultures, were common to all the Insular Manuscripts. Devoid of any figurative imagery, The *Book of Kells'* Carpet page is a pure aniconic rendering, symbolizing the Crucifixion. The unseen presence of Christ's Passion is embedded in the perfectly balanced geometric shapes formed by the embellished frames and the "eight circles." The overall effect is the presentation of a multi-dimensional series of cruciform shapes. Peeking out from behind the outer frame of this series are what seem to be the end pieces of yet another Crucifix. With this subtly occluded meaning, the Carpet page is the manuscript's most mysteriously abstract symbol of Christ.

The Monogram page, although not a pure form of aniconic expression, due to the presence of human and animal figurative representations, has an overall effect similar to that of the Carpet page in that its seemingly abstract presentation denies to a cursory view any ready access to its meaning. Even its massive lettering can escape immediate detection in the midst of the page's bewildering riot of embellishment. Once the letters are made out, one might assume that the page is, like the *Erat autem hora tercia* page in Mark (f. 183r), an ornamental text page, albeit a very elaborate one. But the Monogram page is more than this. The page's central visual device is a monogram, which is a calligraphic motif in which two or more letters are intertwined to form a non-figurative symbol or emblem. Here the monogram is formed by the letters XPI (Chi-Rho-Iota), the first three Greek letters in Christ's name. The symbolic meaning behind this aniconic representation of Christ is to be found in Matthew 1:18–25, the opening words of which the Monogram page presents, *Christi autem generatio* ("Now the birth of Jesus

Christ"). These verses tell the story of His birth to Mary of whose human, *visceral* nature He partook. This human birth was an "incarnation," (literally "into flesh"), a transformation clearly defined in John 1:14: "And the Word became flesh and dwelt among us…"

As if to symbolically complement this notion of Christ's incarnate nature, the page features other images that address this very issue. The most obvious of these is the human face in the center of the page. This could be an image of the Gospel's Evangelist, Matthew. If so, then it is an appropriate allusion in so far as Matthew's symbol is the manuscript's representation of Christ's humanity. Or it may have a more esoteric reference, perhaps an image of Man *qua* Man. This also would be in keeping with the page's theme of Christ Incarnate. Additionally, there is some curious animal imagery, which appears at first to be nothing more than the painter's whimsical doodling, but in fact serves as very pertinent references to the Eucharist, the most sacred partaking of the Body and Blood of Christ Incarnate. One of these is an amusing scene at the bottom left of the page featuring animals that have been variously described as two cats and four mice or two cats and four kittens. Two of the latter are perched on the cats' backs and all four are watching the other two mice (or kittens) nibbling on a shared disc. The disk may very well be a representation of the Eucharist wafer. Slightly to the right of this scene is the image of an otter holding a fish in its mouth. The symbolic meaning of the otter is in question but the fish is an ancient symbol of Christ. So the otter is in the act of "partaking" of the Body of Christ (i.e. the Eucharist wafer).

A more esoteric and decidedly aniconic set of symbols, which offer a comprehensive overview of true meaning of Christ's corporeal nature, is the page's profusion of "triskelia" (from the Greek meaning "three legged") and "triple spirals." The former are the three-pronged spirals set in the disks with yellow backgrounds, and the latter are the larger disks that contain three smaller disks, which themselves have three more disks that revolve around a variant of the "triskelia" shape. These triadic images are of an ancient pedigree and are common to many world cultures. They were particularly prevalent in pre-Christian Celtic art. Their shapes have various symbolic meanings, one of which is the representation of the

mortal world in which all beings are subject to birth, life, and death. Adapted to Christian iconography, they were endowed with these meanings but also came to symbolize the overcoming of this finite sphere through the power of the saving grace of the Trinity, a grace which was bestowed on the world through Christ's mortal vulnerability in death and His subsequent everlasting life in Resurrection.

With the Monogram page we have a perfect example of how the *Book of Kells'* scribes and artists crafted a subtly complex synergistic relationship between symbolic representation and textual content. We can unlock the secrets of the page's illuminations only through a close reading of the text to which its illuminations refer. We have already seen this dynamic at play in the Introductory pages of each Gospel. The Monogram page raises this dynamic to the highest level of sophistication.

On some of the manuscript's pages is an odd figurative symbol that may be an allusion to Christ's aspect as a part of the Trinity, or, the Godhead. One of the clearest examples of this image appears atop the first page of Canon Table II (f.2v). Here we see a bearded figure above whose head are three Crosses. His arms are outstretched in a position that recalls the Crucifixion, and his hands are grasping the tongues of two lions. The three Crosses may well represent the Father, Son, and the Holy Ghost of the Trinity, and the symbol of the lion is very likely a reference to the Resurrection. The meaning here is obvious: Christ died on the Cross, was resurrected, and then ascended to Heaven where he assumed his place in the Trinity. Another Trinity/Godhead symbol appears above Canon Table IV. This haloed figure brandishes two books in what we previously noted is an Osiris pose. Books, symbols of the Word, and the Osiris pose, in part a symbol of Christ as the arbiter on Judgment Day, are here portrayed as a composite of aspects of the Trinity/Godhead. The first page of Canon Table I (f.1v) and the second page of Canon Table II (f.3r) have their own unique representations. The former has a halo, wings, a flowering stem, and a book. The latter has only a hint of wings but, significantly, is perched above a small blue chalice from which sprout a flowering bough and vines. Additionally, it is possible that the shadowy remnant above the list of Hebrew Names (f.1r) was at one time a Trinity/Godhead image. The head of a bizarre zoomorphic image emerges from the top of the Luke's Quoniam page (f.188r), while what are apparently its tiny hind legs dangle from the bottom right of the illumination's frame. What this image is and what it represents is open to interpretation, but if it is a version of the Trinity/Godhead its weird rendering attests to the painter's visionary imagination. The most dramatic Trinity/Godhead image in the manuscript is to be seen on John's Portrait page (f.291v). This folio was one whose upper edge was unfortunately clipped off during a rebinding in the eighteenth century. However, we can still see the bearded jaw of what probably had been a full face and head. Halfway down the illumination, two hands stick out from either side of the frame and at the bottom of the frame we can see the feet of this mysterious figure. That this Trinity/Godhead symbol, which represents the most Holy aspect of the Christian *mysterium tremendum*, is presented partially hidden behind the illumination's frame, may have been the painter's way of suggesting that its true nature is ultimately beyond human understanding. It is also worth noting that the figure's head, hands, and feet suggest a cruciform shape. This "hidden Cross" appears, as already noted, from behind the frame of

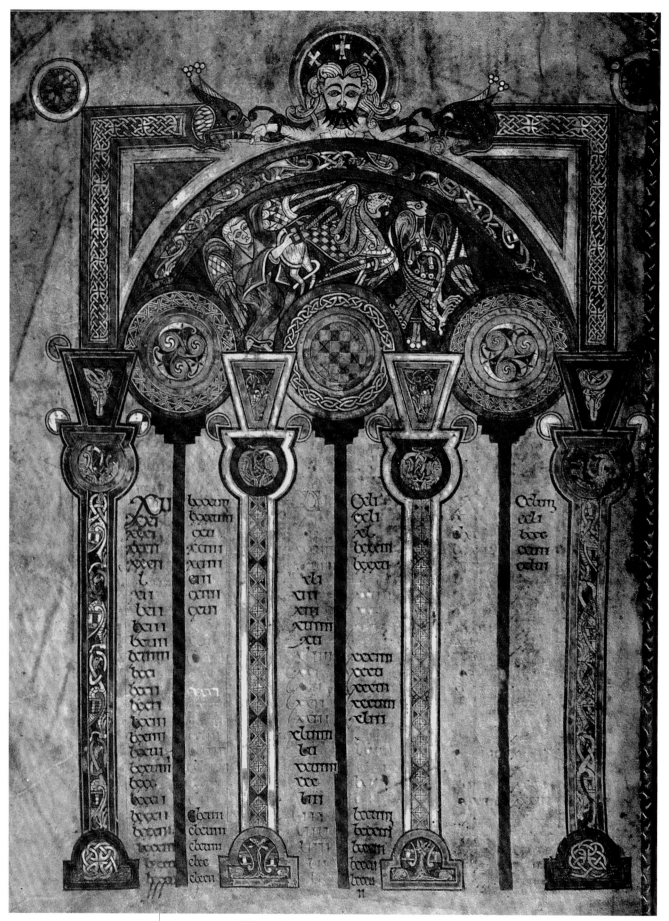

f.2v. Canon Table II. This is the first page of the cross-referenced indexes for Matthew, Mark, and Luke. It features a particularly ornate "Godhead" symbol. ©VISIPIX.COM

the Carpet page (f.33r) as it also does from other pages in the manuscript. (See ff.27v, 28v, 32v, and 129v).

The last symbol of Christ to be considered is a motif that began appearing in Christian art in the middle of the fourth century. Known as the *Majestas Domini* ("Christ in Majesty"), its standard figurative composition presented an image of Christ, usually enthroned, surrounded by four apostles or angels. It is a common motif in many Christian paintings and Insular Manuscripts and was usually rendered in a straightforward pictorial manner. The portrait of Christ (f.32v) is in this pictorial tradition. Here we see Christ seated on a throne flanked by four figures that are probably angels and not the Evangelists. All the other emblems of Christ are present (the Cross, peacocks, the halo, the chalice and sprouting vines, the book symbolizing the Word) making this picture a readily identifiable representation of "Christ in Majesty." A somewhat more obscure presentation of this motif also appears on the Temptation illustration page (f.202v). Here again we see Christ accompanied by four angels. The four angels who appear on these pages (and on folio 285v in Luke) are most likely meant to represent the archangels Michael, Gabriel, Raphael, and Uriel.

There are other *Majestas Domini* representations in the manuscript that are at best oblique and consequently difficult to indentify. This may be because the manuscript's artists sought the quadripartite image's deeper meaning in the Apocalyptic visions from passages in Revelations and Ezekiel. We have included only brief extracts, so the reader may want to consult Revelations 4:1-8 and Ezekiel 1:1-29 in their entirety in order to fully understand how they relate to *Majestas Domini* motif in the manuscript.

In Revelations (4:2) we read:

> At once I was in the Spirit, and lo, a throne stood in heaven, with one seated on the throne!

And in 4:7:

> And round the throne, on each side of the throne, are four living creatures …the first living creature like a lion, the second living creature like an ox, the third living creature with the face of a man, and the fourth living creature like a flying eagle."

And from Ezekiel (1:4 and 1:7):

> As I looked, behold, a stormy wind came out of the north, and a great cloud… and fire flashing forth continuously… And from the midst of it came the likeness of four living creatures…
>
> And this was their appearance: they had the form of men, but each had four faces, and each of them had four wings…and the soles of their feet were like the sole of a calf's foot.

He goes on to describe the creatures' faces (1:10):

> As for the likeness of their faces, each had the face of a man in front; the four had the face of a lion on the right side…the face of an ox on the left side…and the face of an eagle at the back.

With these esoteric and dream-like qualities found in Revelations and Ezekiel in mind we are better able to identify the manuscript's more arcane references to the *Majestas Domini* motif. For example, on the Canon Table I page (f.1v) the strangely composite image of the Evangelists in the tympanum features Matthew, the human symbol, sprouting wings, as does the calf image of Luke, and the lion image of Mark. The same kind of composite representations appear also on the first page on Canon Table II (f.2v) where Luke looks like an eagle with a calf's head, and Mark, an eagle with a lion's head. The composite zoomorphic images recall Ezekiel's vision of God from Ezekiel.

In addition to the protean, Ezekiel-like visionary imagery in which the Evangelists are portrayed in the tympanums of folios 1v and 2v there also appears an aforementioned "Godhead" at the top of these Canon Table. It is suggested that the interrelation of these images, four "beasts" and a 'Godhead' (i.e. Christ Risen), forms an obscure representation of the quadripartite imagery which is used to herald the ineffable presence of the *Majestas Domini*, Christ in Majesty. In the final analysis, this presence informs all of the imagery covered in this survey, from the smallest decorated initial to the most complexly rendered full-page illumination, and is the ultimate source of the works enchantingly mysterious power.

Conclusion

It is appropriate that we end our survey of the *Book of Kells* with this reference to the most esoteric of Christ's symbols. Admittedly, our analysis of this and all the other representations we have addressed has provided only a cursory glimpse of the manuscript's wondrous achievement. In truth, one could spend years in rigorous academic exegesis of each of its artistic elements and still be unable to adequately describe what the manuscript is truly about. This is perhaps as it should be.

The Book of Kells is first and foremost a work of Irish Christian devotional art that was to serve as a Holy object for public display in the church sacristy. No less than the Cross and the Altar, it was designed to inspire awe and reverence in the Kells' congregants. Its imposingly bejeweled, ornately rendered metalwork covers and its profusion of spectacularly illuminated pages had a purely sacramental purpose. It is not a scholarly reference text but rather a visual witness to the glory of Christ's Life and Resurrection and to the *mysterium tremendum* of His eternal living presence. As such, the Book of Kells represents an indefinable act of faith on the part of those who created it and those who worshipped before it.

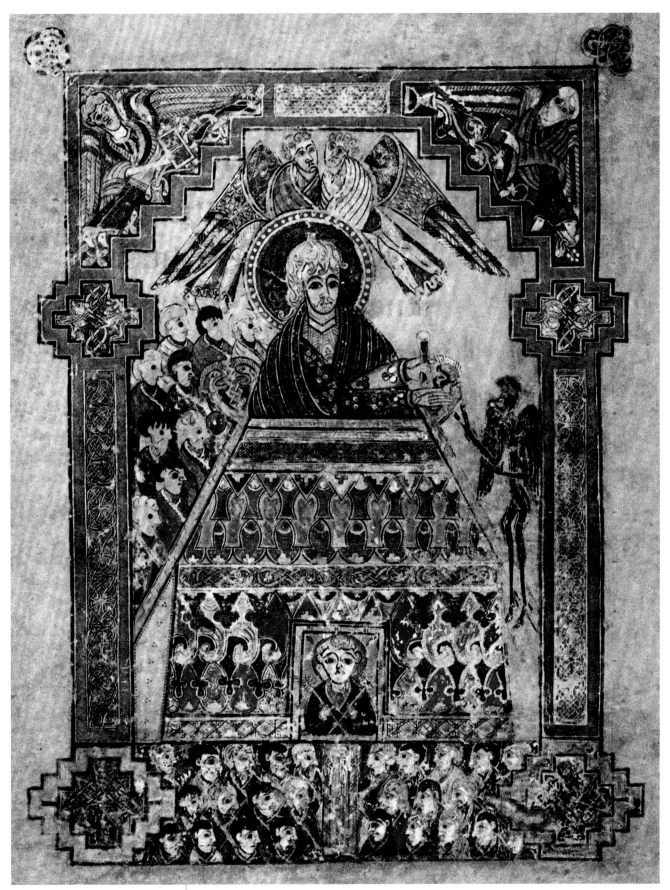

f.202v. The Temptation Illustration. Thematically, this is a very complex illustration. Not only does it contain a depiction of Christ's confrontation with Satan but also imagery that suggests the continuation of His mission in carrying the Gospel after the Temptation story. It also contains elements of the Majestas Domini *motif.* ©VISIPIX.COM

PLATES

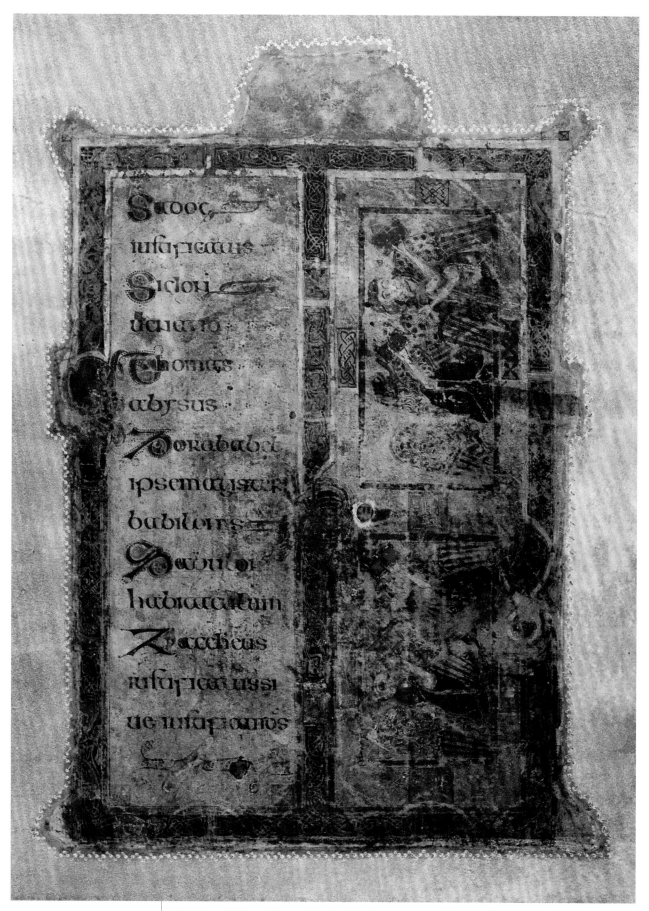

f.1r. List of Hebrew Names. On the left there is a partial list of Hebrew names found in the Gospel of Matthew; on the right, a vertical display of symbols of the four Evangelists, in order of appearance from top to bottom, Mark, Matthew, John, and Luke. ©VISIPIX.COM

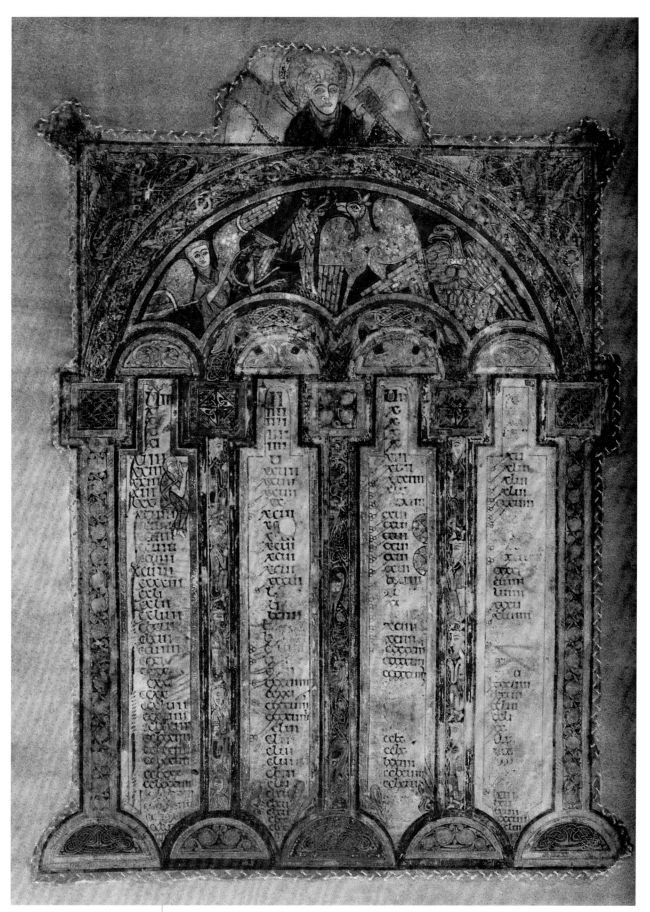

f.1v. Canon Table I. This table displays the cross-referenced index for all four Evangelists. Their symbols appear in the arcade's tympanum as Matthew, Mark, Luke, and John, all facing the center. The mysterious figure at the top of the frame may be a representation of the "Godhead." ©VISIPIX.COM

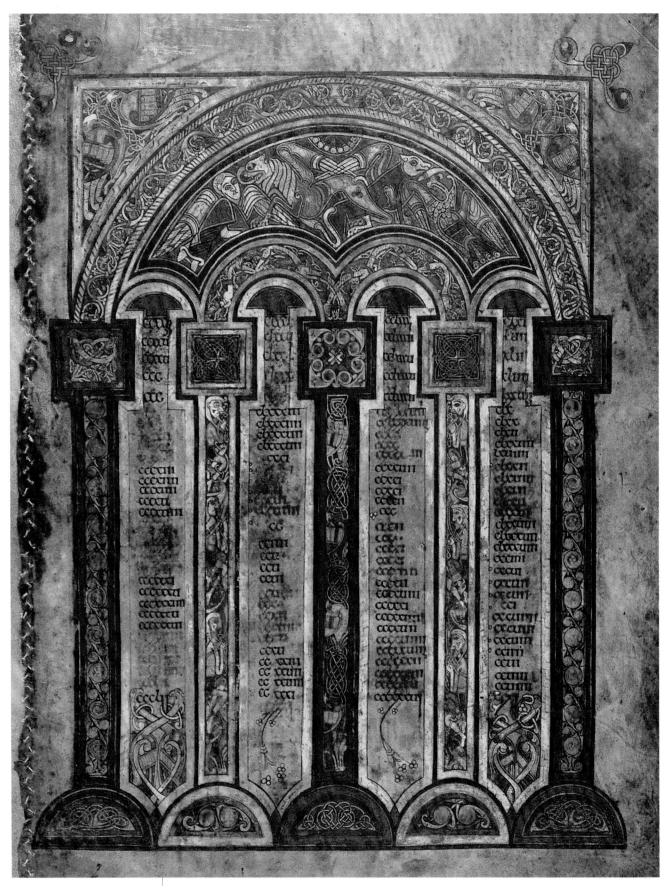

f.2r. Canon Table II. The second page of Canon Table I features the Evangelists in altered positions with Mark facing Matthew and Luke facing John. The faded dome atop the frame is not a missing "Godhead" but rather a partial "bleed-through" from this folio's obverse. ©VISIPIX.COM

f.3r. Canon Table III. The second page of Canon Table II has a "Godhead" image (note the chalice with flowering vines directly below it). There is also has an inexplicable second image, perhaps of Matthew or an angel, in a disk below the arcade's tympanum. ©VISIPIX.COM

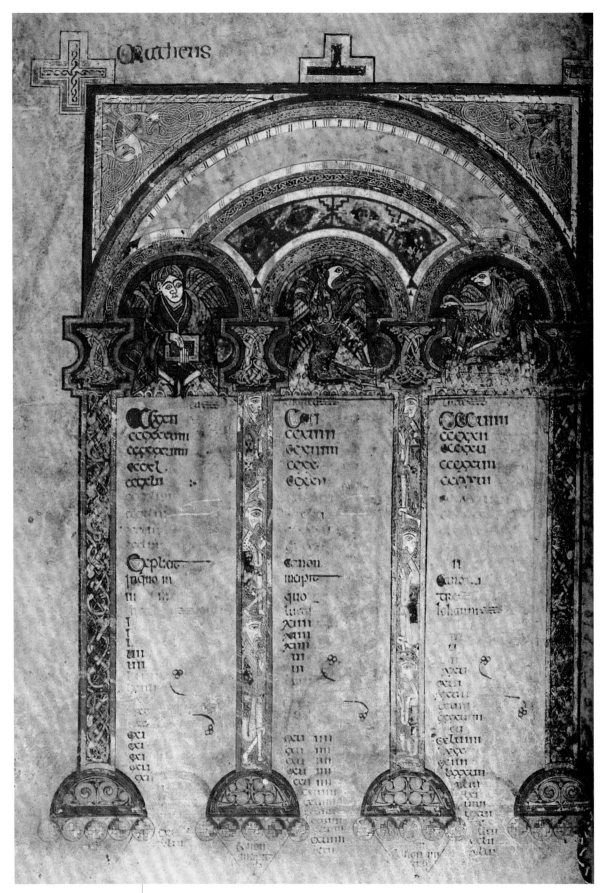

f.3v. Canon Table II and III. This is the disordered Canon Table page that at first refers to Matthew, Mark, and Luke and displays their symbols in the tympanum, but it has also crammed the list from Canon Table III for Matthew, Luke, and John at the lower right of the arcade's columns. John's eagle symbol does not appear anywhere on this page. ©VISIPIX.COM

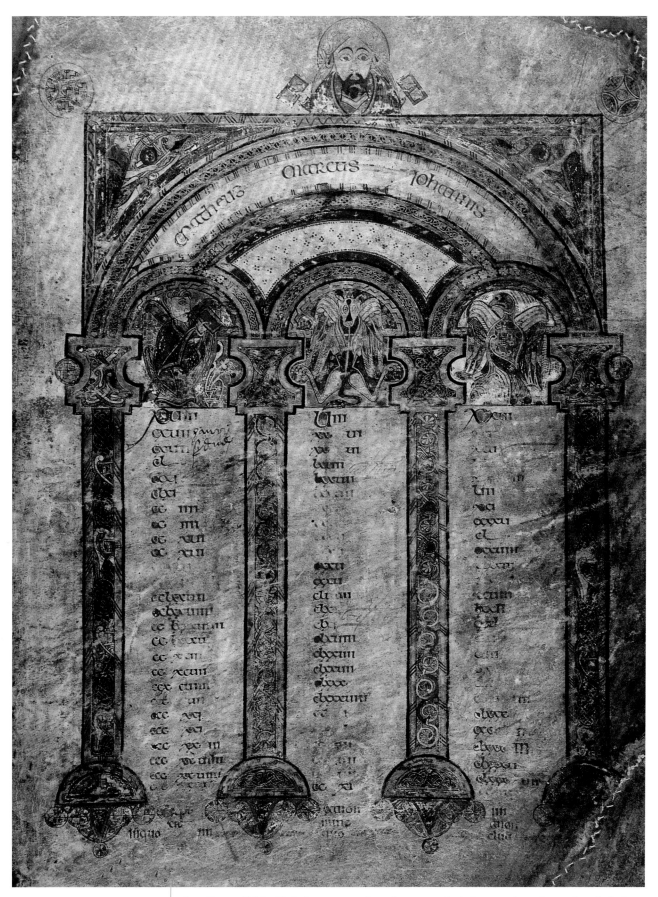

f.4r. Canon Table IV. Order is restored on this page, which features the index and symbols for Matthew, Mark, and John. Atop the arcade's frame is a book-brandishing "Godhead." Note the relative lack of decoration in the tympanum where the names Matheus, Marcus *and* Iohannis *have been inscribed.* ©VISIPIX.COM

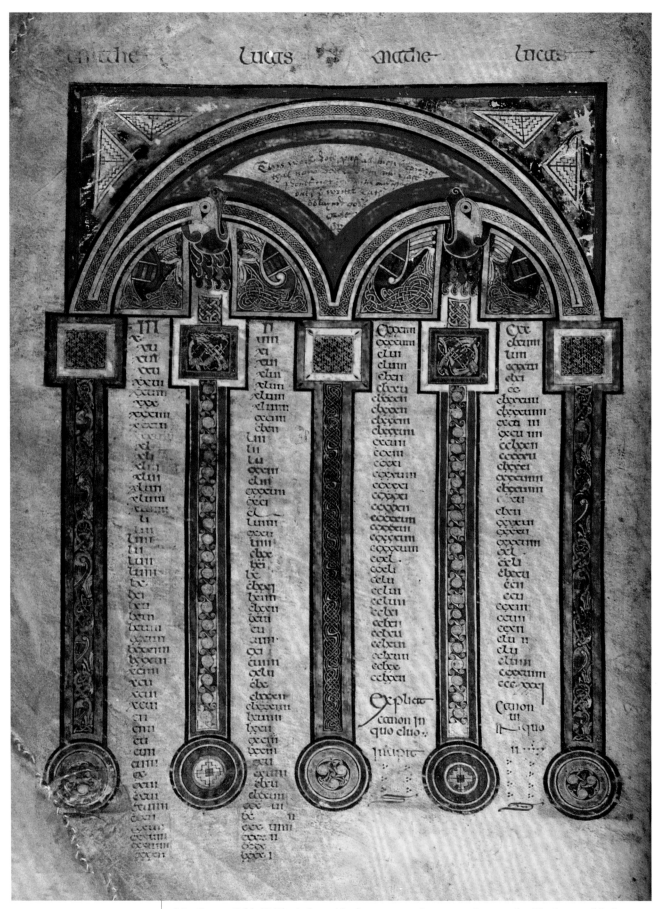

f.4v. Canon Table V. The index table that presents the cross-references for Matthew and Luke is noteworthy for its lack of Evangelist symbols. Only the names Mathe[us] *and* Lucas *appear twice at the top of the arcade's frame.* ©VISIPIX.COM

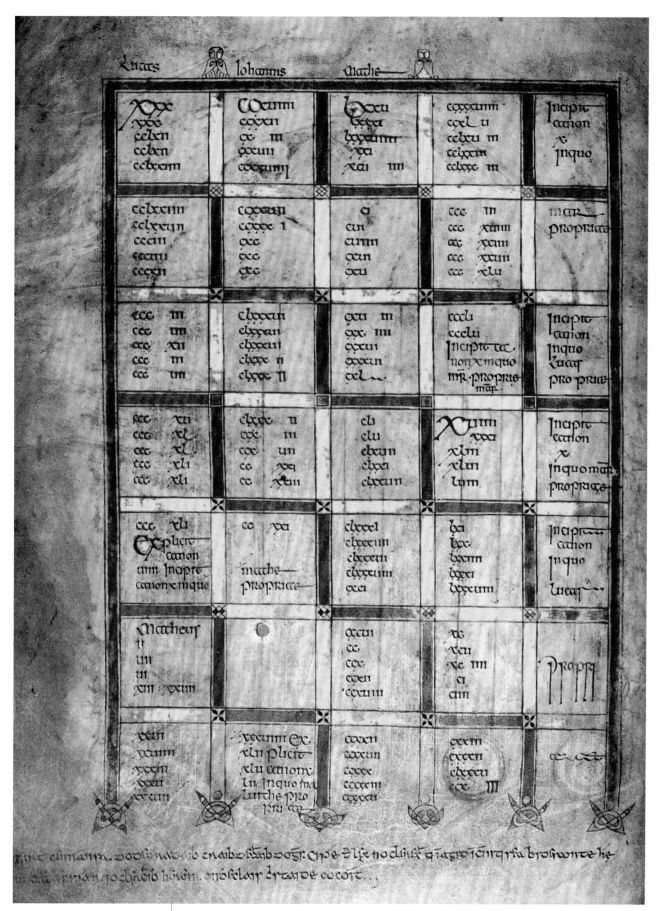

ff. 5v–6r. For the two last canon table the scribes abandoned the program of designing the tables in arcades, using colored bars to organize the references. ©VISIPIX.COM

f.13r. Beginning of the Breves causae *of Mark. The decorated capitals read:* Et erat Iohannis baptizanz Ihm et venit. *("And John was baptizing Jesus and he came…")* ©VISIPIX.COM

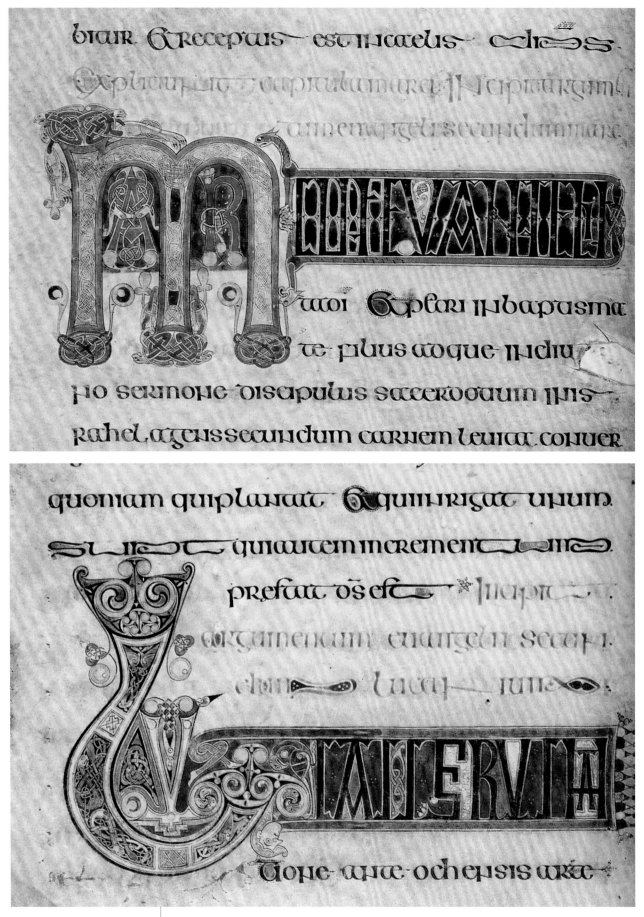

ff.15v & 16v (details). The openings of the Argumenta of Mark and Luke. ©VISIPIX.COM

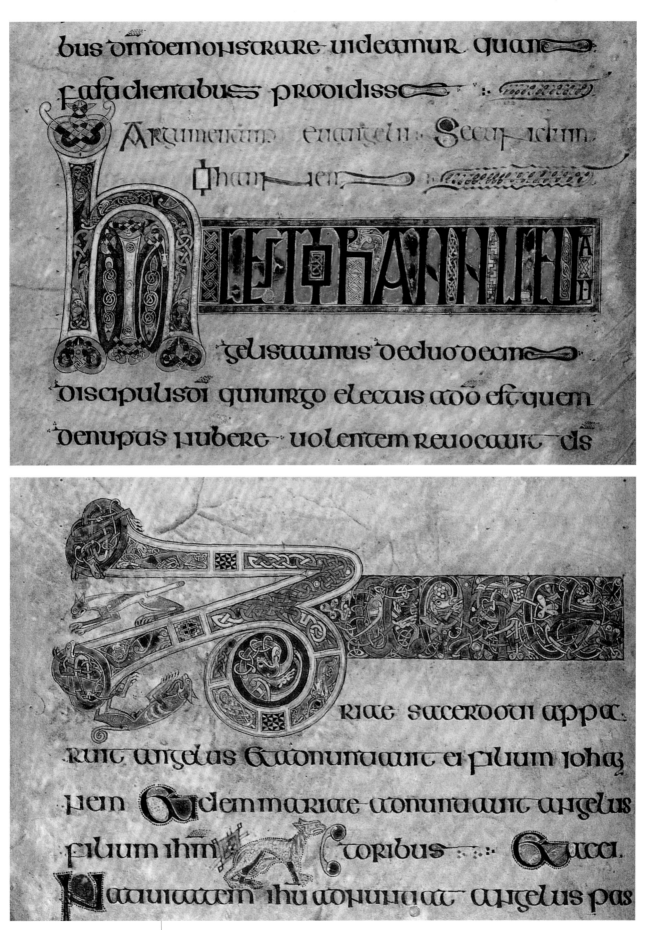

ff.18r & 19v (details). Beginning of the Argumentum *of John and the* Breves Causae *of Luke.*

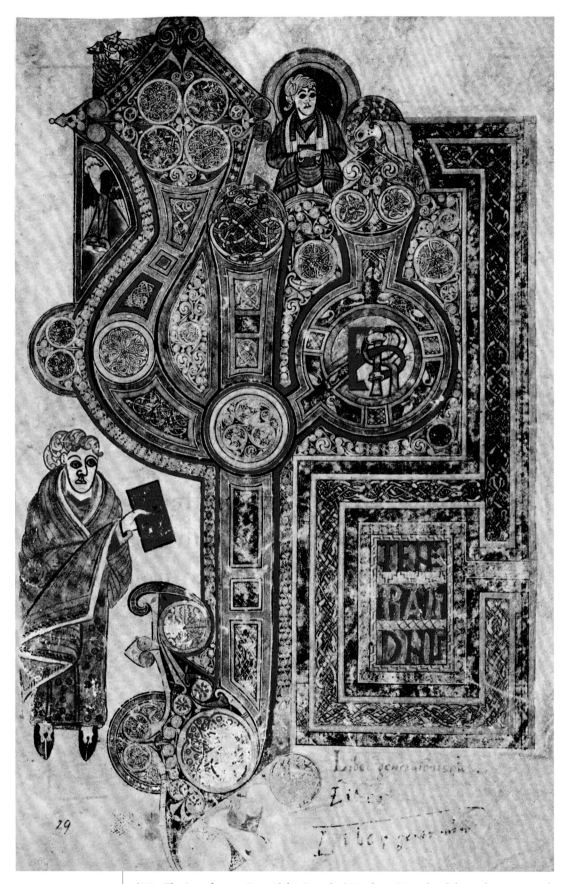

f.29r. The Introductory Page of the Gospel of Matthew. Here the elaborately ornamental text presents the opening words of Matthew, Liber generationis, which begins the genealogy of Christ. The figurative image at the top is probably Matthew. Who the figure is at the lower left remains in question as does the faceless figure on the upper left. The latter may be an unfinished representation of the Evangelist or perhaps an angel. ©VISIPIX.COM

genuit achaon
achas h genuit
ezechiam eze
chias autem
genuit manas
sem manasses
h genuit am
os amos autes
genuit iosiam
iosias h genuit
iechoniam &
fratres eius
inratus migra

tionem babylo
nis · et post tra
us migratione
babilonis · ie
chonias genuit
salathiel sala
thiel h genuit
sorobabel · so
robabel autes
genuit abiud
abiud autem
genuit eliachi
eliachim au

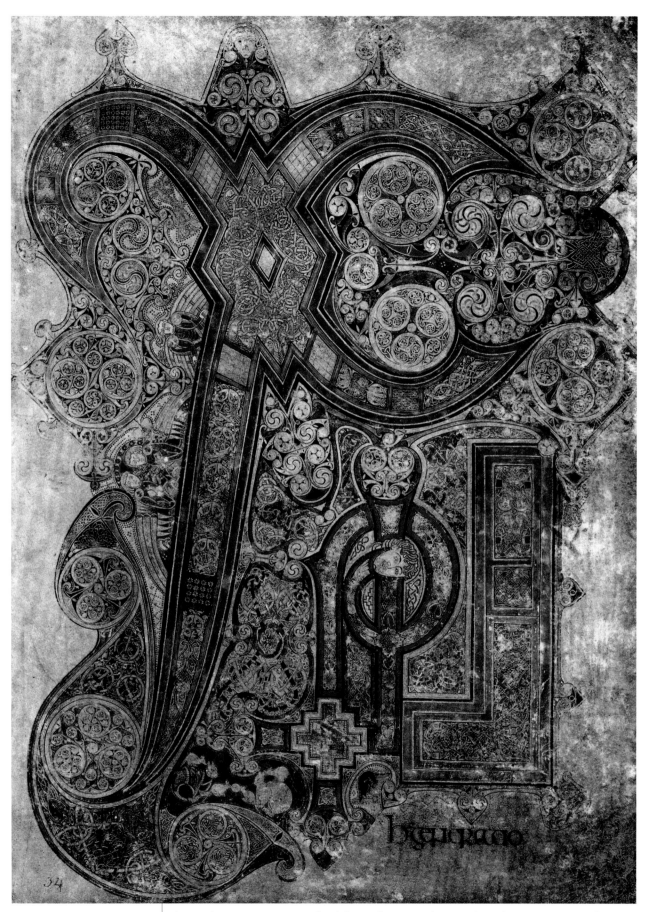

f.34r. The Monogram Page. The elaborate letters on this page form the Monogram of Christ XPI (Chi-Rho-Iota), the first three Greek letters in His name. This page is the beginning of Matthew 1:18: Christi autem generatio ("Now the birth of Jesus Christ"). ©VISIPIX.COM

f.40v. Matthew 5:3–10. The Beatitudes are highlighted by a uniquely decorated bar running down the outer margin. The human and animal figures with their repeating motifs are each the initial "B", the beginning of each verse. ©VISIPIX.COM

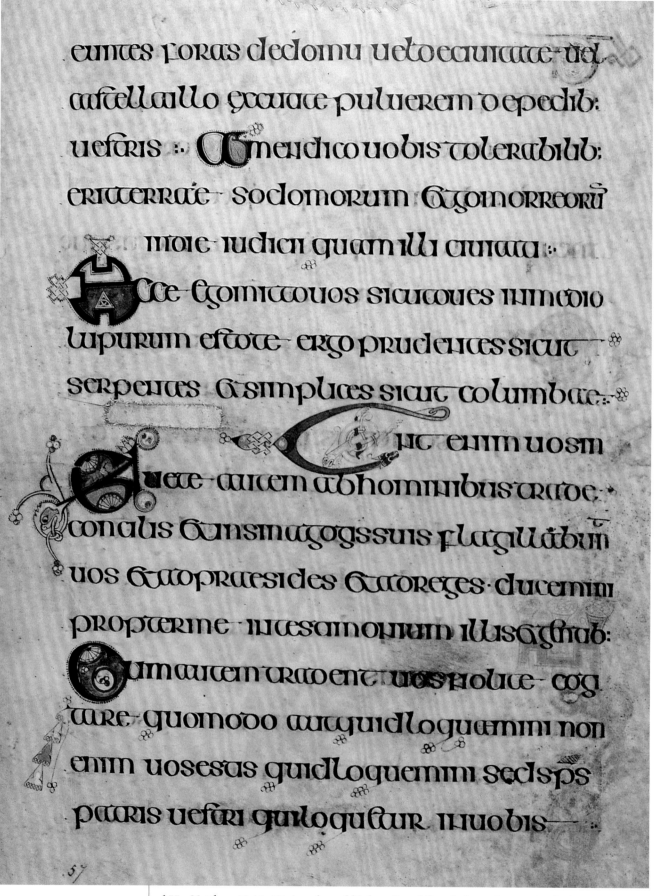

euntes foras dedomu ueldecuitate uel
castellaillo excutite puluerem depedib:
uestris :. Amendico uobis tolerabilib:
eritterrae sodomorum &gomorreoru
mote iudicii quam illi ciuitati :.
Ecce egomitto uos sicutoues inmedio
luporum estote ergo prudentes sicut
serpentes &simplices sicut columbae:.
Cauete autem abhominibus trade.
conalis &transmagogssuis flagallabun
uos &adopraesides &adoreges ducemini
propterme intestimonium illisetgentib:
Cum autem trad ent uos nolite cog
tare quomodo autquid loquemini non
enim uosestis quidloquemini sedsps
patris uestri quiloquitur inuobis——:.

f.57r. Matthew 10:14–20. A snake and bird are found directly beneath verse 16: "…be ye therefore wise as serpents, and harmless as doves." ©VISIPIX.COM

omnisergo quiconfitebiturme coram ho

minibus confitebor &egoeum coram pa

tre meo quiincaelis est :.

Uiautem negauerit mecoram homi

nibus negabo &ego &egoeum cora

patremeo quiincaelis est :.

Nitearbitrari quiauenirim pacem

mittere interram nonueni pacem

mittere sedgaudium ueni

enim separare filium hominem aduer

sus patrem suum &filiam aduersus

matrem suam &nurum aduersus so

crum suam &inimici hominisdomestici

Uiamat patrem autmatrem plus

quamme nonestme dignus &qui

amat filium autfiliam plusquamme

nonme dignus &quinonaccipit crucem

suam & sequatur me nonest me dignus·

Uiniuenit animam suam perdoe—

illam · & quiperdiderit animam

suam propterme inuenit eam :·

Utrecaperit uos mereapit · & qui

mereapit recapiteum quimemissit·

Utrecapit propheram innomine·

profetae meradem profetae·

accipiet· & quirecapit iustum innomine

iusti meradem iusti accipie—·

Quicumque potum declerit uni

examhimis istis calicem aquae—fri

gidae tantum innomine·discipuli amen

dicouobis nonperdet meradem suam:·

factumest cumconsummasset

ihs uerbahaec praecipiens duo

decim discipulis suis transit inde ut

59

Uespereautem facto solus eratibi na.
uicula autem inmechio mari iactabatur
fluctibus eratautem illis uentus conta
rius quarta autem uigiliahoctis uenit
adeos ambulans supramare Gandau
teseum supramare ambulantemtur
batisunt dicentes quiaphantasmaest
aprotimore clamauerunt factimq:
ihs loguaisest eis dicens habete fidu
ciam Egosum Holite timere ∴
Respondens autem petrus dixit
Dñe sides iubeme uenire adte
superaguas adipse aduenit Gdiscñ
dens petrus deuauicula ambulabat
supermare utueniret adihm uidens
uero uentum ualidum timut Gcum
coepisse mergi clamauit dicens dñe

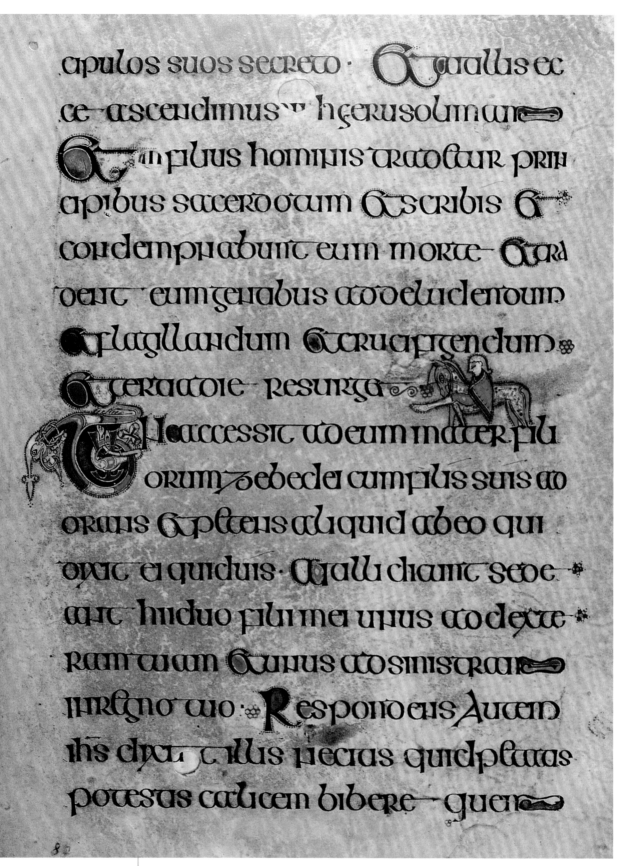

f.89r. Matthew 20:17–22. The horseman points with his leg to the verse ending with the word resurget, *which reads in it entirety: et tradent eum gentibus ad deludendum et flagellandum et crucifigendum et tertia die resurget. ("And [they] shall deliver him to the Gentiles to mock, and to scourge, and to crucify [him]: and the third day he shall rise again.") The Book of Kells regularly deploys marginal and intertextual figures to call attention to passages referring to the Resurrection.* © VISIPIX.COM

neguenubent neguenubentur sede-
runt sicut angeli di in caelo · De
resctione mortuorum autem non
legisas quod dictum est a do dicen-
te uobis · Ego sum ds abraham
& ds isac · & ds iacob non est
ds mortuorum sed uiuentium ·· Et
audientes turbae admirabantur
in doctrina eius
Pharissei autem cum audien-
tes quintum possuisse saduc
eis sillentium conuenierunt in
unum aduersus eum & interroga-
uit eum quidam ex ipsis legis doc
tor temptans eum magister quod
est mandatum magnum & primum

*f.97v. Matthew 22.30–36. The opening of the oversized initial "P" is filled with a red-headed
bearded figure, a clear image of the Jewish Pharisee. The "P" itself seems to be formed from an
angel, suggesting that God will trap the Pharisees within their own snares.* ©VISIPIX.COM

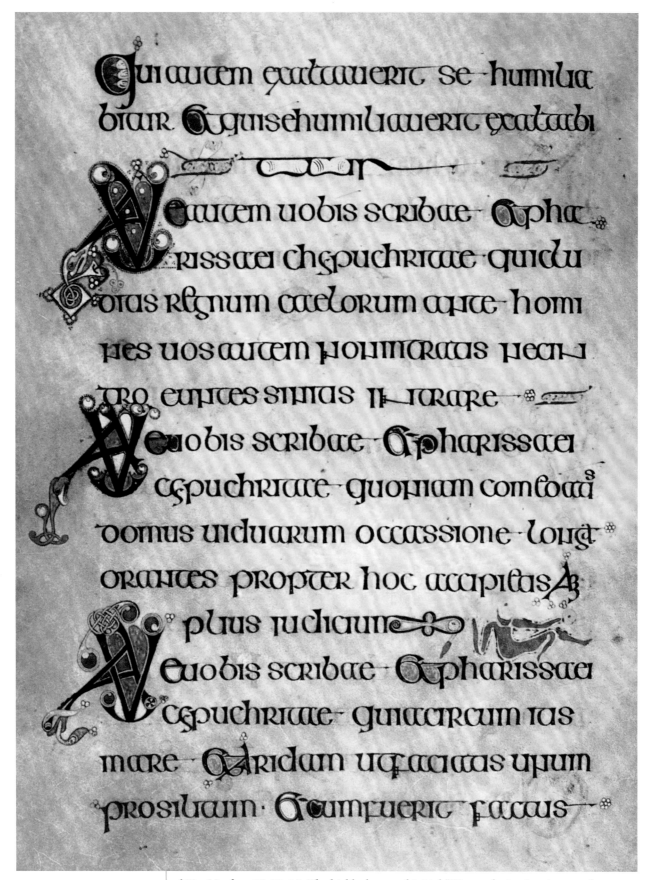

f.99v. Matthew 23:12–15. The highly decorated initial "V"s emphasize Jesus' repeated condemnation of the Pharisees ("Woe to you…"). ©VISIPIX.COM

paratam uobis aconfacatone mund

Esurini enim &dedisas mihi mæ

ducare Saui &dedifas mihi bi

bere Hospes eram &collegis

as me Pudus eram &coperu

isas me Infirmus &uisatafas

me Icarcere fui &uientfas

come Tunc respondebunt

ei iufa dicentes dñe quando te ui

dimus essurientem & pauimus te

Aut siaentem &dedimus ubi

poam Quando autem te uidimus

hospitem &colligimus te

Aut nudum &cooperuimus te

Aut quando te uidimus infirmæ

uel incarcere &uenimus adte

Respondens rex dice illis

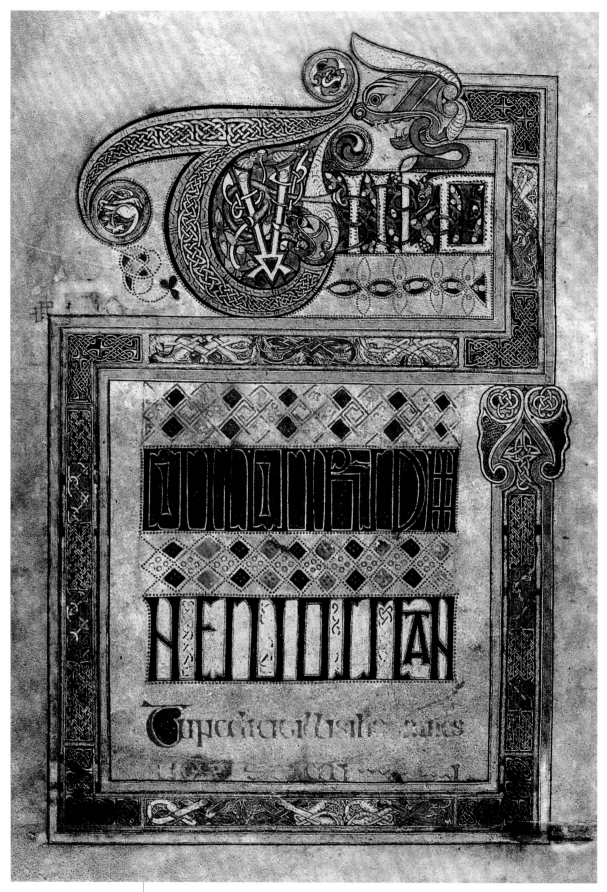

f.114v. The Aftermath of the Arrest. Matthew 26:31. This page of ornamental text bears the words, Tunc dicit illis Ihs omnes vos scandalum. ("Then Jesus said to them: you will all be scandalized."). It is the obverse of the Arrest Illustration. ©VISIPIX.COM

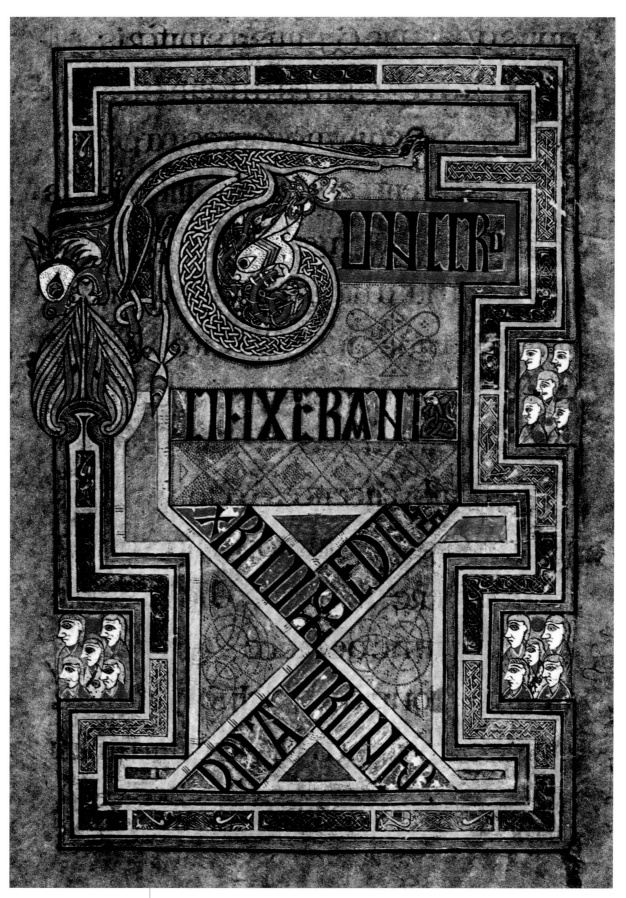

f.124r. The Crucifixion. The ornamental text on this page presents the verse from Matthew 27:38: Tunc crucifixerant XPI cum eo duos latrones. ("Then were there two thieves crucified with him.") Scholars believe that the blank facing page, folio 123v, was intended for an illustration of the Crucifixion. ©VISIPIX.COM

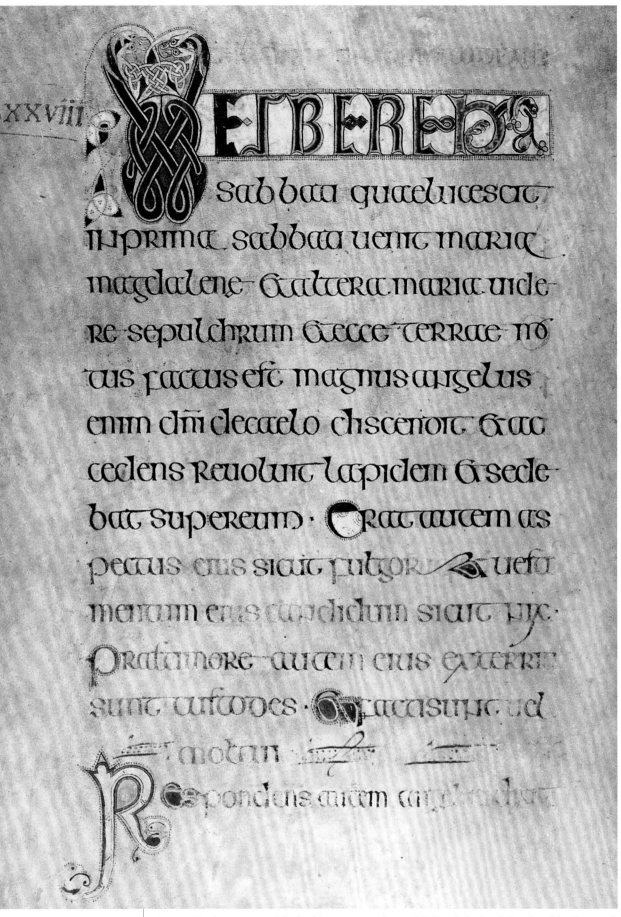

XXVIII VESPERE sabbati quae lucescit inprima sabbati uenit maria magdalene & altera maria uidere sepulchrum & ecce terrae motus factus est magnus angelus enim dñi decaelo discendit & accedens reuoluit lapidem & sede bat supereum · Erat autem as pectus eius sicut fulgor & uesti mentum eius candidum sicut nix · Praetimore autem eius exterriti sunt custodes · Et facti sunt uel mortui · Respondens autem angelus dixit

f.127v. Matthew 28:1–5. The highly ornamented initial "V" and the brightly colored background to Vespere *bear witness to the joyful news this chapter brings of the Resurrection.* ©VISIPIX.COM

Quoaudito discipulis uenerunt &tu
lerunt corpus eius &possuerunt illud
inmonumento ·:·

Conuenientes apostoli adihm
renuntiauerunt illiomniaquaegerant
&docuerat it · ·

Aitillis uenite seorsum indeser
tum locum &requiescite pussil
lum erant enim quiueniebant &redie
bant multa &necmanducandi spacium
habebant ·:·

Ascendens innaui habierunt
indesertum locumseorsum &ui
derunt eosabeuntes &cognuerunt
multa &pedestrae &deomnibus ciuita
tibus occurrerunt illuc &praeuenerunt
eos &exiens uidictturbam multam ihs

f.147v. Mark 6:29–34. The three ornamented ET monograms stress the execution of John the Baptist, which foreshadows the Passion and Crucifixion. ©VISIPIX.COM

patris nostri dauid ossanna in excel

intrauit hierusolima in tem

plum & circum spectis omnib:

cum iam uespera essa hora

exiit in bethaniam cum duodecim

discapulis suis · & alia die cum ea

rent abethania cum ca · essuriit usq;

uidisse alonge ficum habentem folia

uenit uidere siquid forte inuenira

in ea & cum uenisse ad eam nihil in

uenit praeter folia non enim erat

tempus ficorum & respondens dixit

ei iam non amplius in aeternum quis

quam fructum exte manduca & au

diebant discapuli eius ·

ueniunt in hierusolimam

& cum introise templum

inuenerunt sicut dixerat illis &pa

rauerunt pascha :

Uespere autem facto uenit

cumat · &oiscumberabus eis&

maiducarabus ait illis IIos

Aendico uobis quiaunus ex

uobis mexado& quimaiducat

mecum

Tlli coeperunt contristar,

&oicere ei singillatim num

quid ego sum

Qui ait illis unus oeouooecim

quinnangt mecum manum in

catano· &filius quidem hominis

uadit sicut scriptum est deeo

uaeautem hommi illi perquem

filius hominis tradetur

ff.176v, 177v, 178r–179r, 181v–184r. Mark 14:16–15:36. Pulliam notes the increasingly elaborate ornamentation in these pages recounting Christ's Passion as well as in the corresponding folios in Matthew and Luke. The decoration keeps pace with the heightened emotional intensity in the narrative. ©VISIPIX.COM

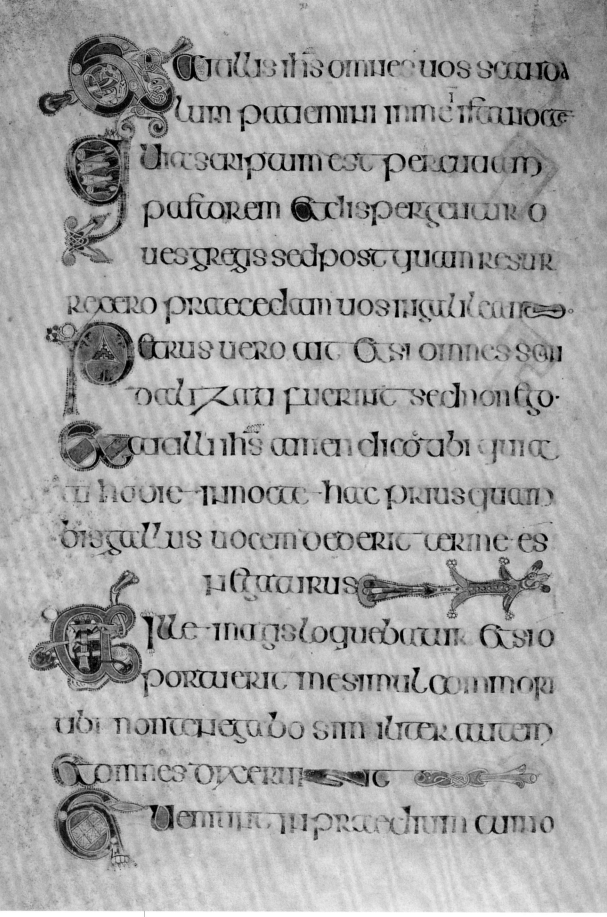

et ait ihs omnes uos scanda
lum patiemini in me in istanocte
ut scriptum est percutiam
pastorem &dispergentur o
ues gregis sedpostquam resur
rexero praecedam uos ingalileam
Petrus uero ait &si omnes scan
dalizati fuerint sednon ego
et ait ihs amen dico tibi quia
tu hodie in nocte hac priusquam
bis gallus uocem dederit terme es
negaturus
Ille magis loquebatur &si o
portuerit me simul commori
tibi nontenegabo similiter autem
&omnes dicerent
uenerunt in praedium cuio

ecce qui메 tradet me prope est

Adhuc eo loquente uenit

iudas scarioth unus ex xii

Et cum eo turba multa cum gladiis

Et fustibus a summis sacerdotab:

Et scribis et senioribus

Dedit autem traditor eius sig

num dicens eis quemcumque

osculatus fuero ipse est tenete eu

et adducite Et cum uenisset statim

accedens ad eum ait rabbi Et oscula

tus est eum et illi manus inicerunt

in eum et tenuerunt eum

Unus autem quidam de circum

stantibus educens gladium

percussit seruum principis summi

sacerdotis et amputauit illi auri

culam eius

Respondens ait illis ihs tam
quam adlatronem existis cu
gladiis & fustis conpraehendere me
cottidie eram apud uos intemplo
docens & nontenuistis sed ut
impleantur scripturae

Tunc discipuli eius reliquerunt eu
omnes & fugerunt

Adoliscens autem quidam se
quebatur eum amictus sin
done supernudo & tenuerunt eum

At ille eiectas sindone nudus fugt
abeis

Et adduxerunt ihm adsummu
sacerdotem & conuenerunt
omnes sacerdotes & scribae &senio
res

Petrus autem secutus est eum

alonge usque intratrium sum

mi sacerdotus & sedebat cum

ministris & ad ignem faciebat se calefa

ciens uero sacerdotes & omne

consilium querebant aduersus

ihm testimonium uteum morti tra

derent nec inueniebant multa enim

testimonium falsum dicebant ad

uersus eum & conuenientia testimo

nia | ioi ierra ic

Quidam surgentes falsum

testimonium ferebant aduer

sus eum dicentes quoniam nos au

diuimus eum dicentem ego dissoluam

templum hoc manu factum & per

triduum Aliud nonmanu factum

erat uinctus qui fecerat insidtaone·
homiadium Ocumascendisset tur
ba coepit rogare· sicut semper fa
ciebat illis perdiem sollemphem
utdimittere unum uinctum psilati
autem respondit eis Odixit uultis
dimittam uobis Regem iudeorum sa
ebat enim quod permuidiam trddi
o erunt eum summi sacerdotes
Ponatfices autem contat
uerunt turban utancgis
barbam dimittere eis
Ilatus autem iterum respon
dens at illis quid ergo uultis
uiciciam Regi iudeorum alli da
mabant iterum dicentes cruafige·
eum pilatus uero dicebat eis quid

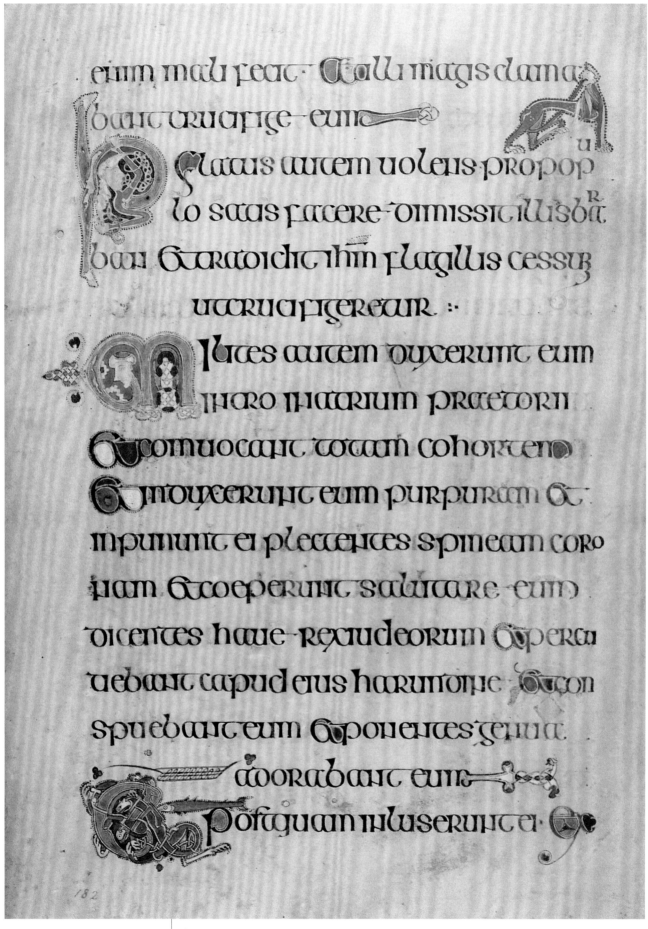

enim mali fecit · Calli magis clama
bant cruafige · eum
Pilatus autem volens pro pop[u]
lo satis facere · dimisit illis ba[r]
ban & tradidit ihm flagillis cessu[m]
ut crucifigeretur · :·
Milites autem duxerunt eum
intro in atrium praetorii
& comuocant totam cohortem
& induxerunt eum purpuram &
imponunt ei plectentes spineam coro
nam & coeperunt salutare eum
dicentes haue · rex iudeorum & per cu
tiebant caput eius harundine · & con
spuebant eum & ponentes genua
adorabant eum
Postquam illuserunt ei

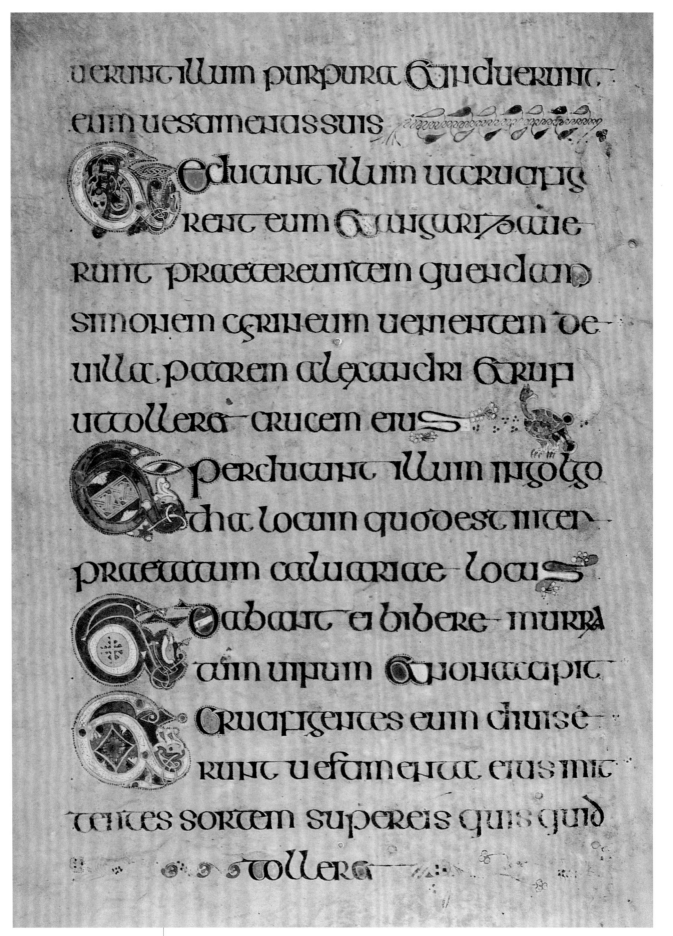

uerunt illum purpura & induerunt
eum uestmentis suis
educunt illum uccruapg
rent eum & angurizaue
runt praetereuntem quendam
simonem cyrineum uenientem de
uilla patrem alexandri & rufi
uttolleret crucem eius
perducunt illum ingolgo
tha locum quod est inter
praetatum caluariae locus
dabant ei bibere murra
tum uinum & non accipit
crucifigentes eum diuise
runt uestimenta eius mit
tentes sortem super eis quis quid
tolleret

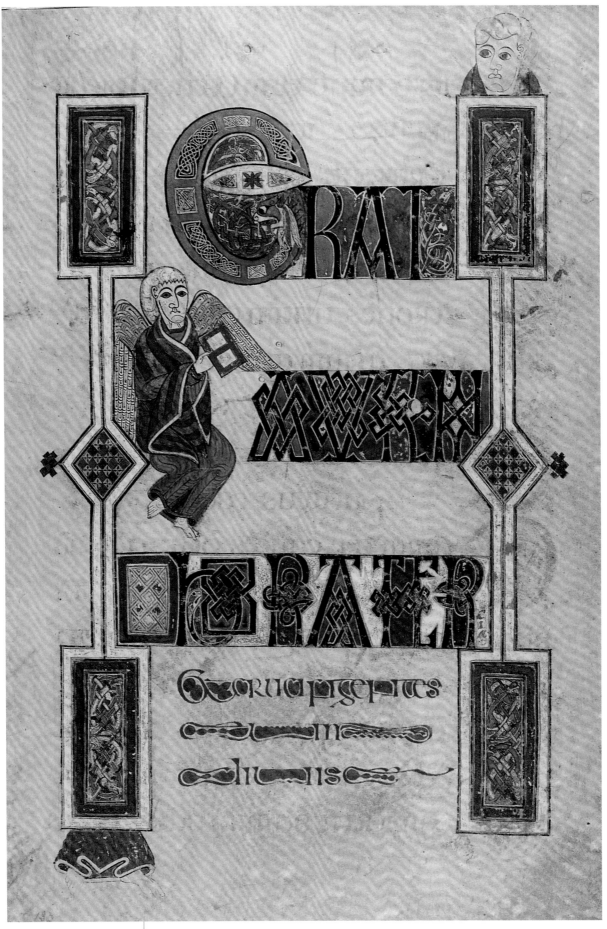

f183r. ©VISIPIX.COM

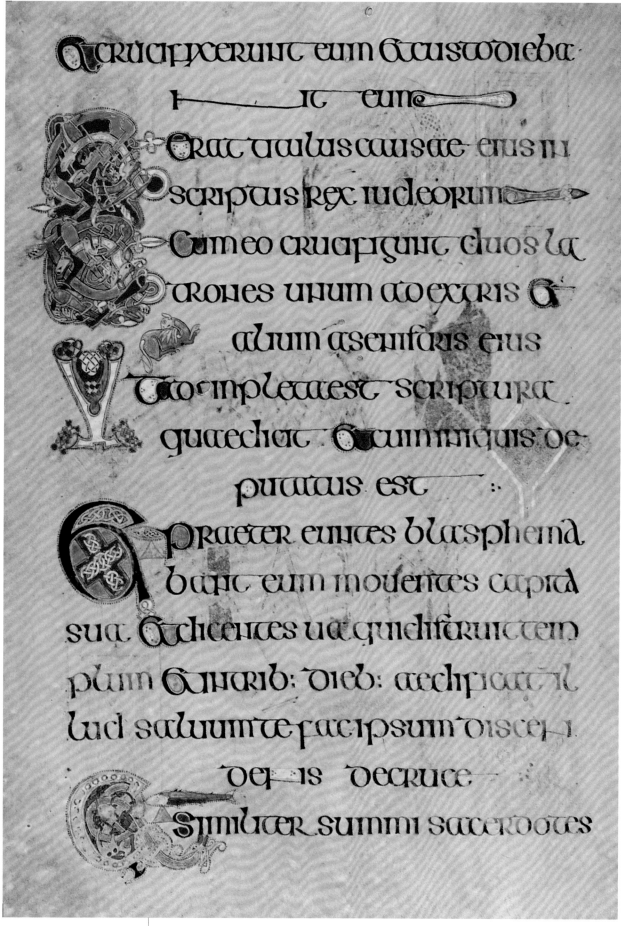

Crucifixerunt eum & custodieba
nt eum
Erat titulus causae eius in
scriptus rex iudeorum
Cum eo crucifigunt duos la
trones unum ad extris &
alium a sinistris eius
& completa est scriptura
quae dicit & cum iniquis de
putatus est
Praeter euntes blasphema
bant eum mouentes capita
sua & dicentes uah qui destruit tem
plum & in trib: dieb: aedificat il
lud saluum te fac ipsum discen
dens de cruce
Similiter summi sacerdotes

inludentes adalter utrum cumscr
bis dicebant alios saluos fecit se
ipsum nonpotest saluum facere
xps rexisrahel discendat nunc
decruce utuideamus &crecdamus ei
Quicumeo cruaffixa erat ᴊᴛ
col luiaebatᴊan eᴊ
facta hora sexta tenebre
factaesunt supertotam
terram usque Adhoram nonam
hora nona exclamauit
ihs uoce magna dicens
helio helio lamasa bcthani quo
est inᴛerprafatum dsds meus ut
guid me direliguifa &guidam
decircumfatabus Audientes dice
bant ecce heliam uocat ifte

f.187v. The Ascension. This peculiarly designed page refers to Mark 16:19, which relates Christ's Ascension with "So then the Lord Jesus, after he had spoken to them, was taken up into Heaven, and sat down at the right hand of God." The page seems to be unfinished. It may have been intended to contain a more elaborate depiction of the Ascension. ©VISIPIX.COM

Quidem multa conatisunt ordinare
narrationem quaennobis complusesun
rerum sicut tradiderunt nobis qui
a bi nno ipsi uiderunt Omnis
tri fuerut sermonis uisum
et Omihi cosecuto a principio
omnibus diligenter exordine
ubi obaene scribere theophile
utcognoscas eorum uerborum
dequibus eruditus es ueritatem

FUITINDIEBUSHERD

Chs regis iudiae sacer
dos quidam nomine zacharias
deuice abias Guxor illi defilia
bus aeron Gnomen eı elızabeth

f.188v. Luke 1:1–5. This is beginning of the Gospel of Luke immediately following
the Quoniam page (the first word in the Gospel). The first four verses are Luke's preface.
The cleverly designed initial "F" begins the fifth verse, the start of the Gospel narrative.
A fish, a Christ symbol, serves as the central bar of the "F". ©VISIPIX.COM

ui	fuit	machat
ui	fuit	icce
ui	fuit	semei
ui	fuit	ioseph osse
ui	fuit	iuda
ui	fuit	iohanna
ui	fuit	ressa
ui	fuit	zorbba
ui	fuit	salathiel
ui	fuit	╮eri
ui	fuit	melchi
ui	fuit	addi
ui	fuit	cosun
ui	fuit	elmadam
ui	fuit	er
ui	fuit	iesu
ui	fuit	eliezer

uu	fuit	zorim
	fuit	mathat
	fuit	leui
	fuit	semeon
	fuit	iuda
	fuit	ioseph
	fuit	iona
	fuit	eliacim
	fuit	melcha
	fuit	menna
	fuit	mathathia
	fuit	nathan
	fuit	dauid
	fuit	iesse
	fuit	obed
	fuit	boos
	fuit	salmon

VI	fuit	haaasor
VI	fuit	aminadab
VI	fuit	aram
VI	fuit	asrom
VI	fuit	fares
VI	fuit	iudae
VI	fuit	iacob
VI	fuit	isaac
VI	fuit	abracham
VI	fuit	charae
VI	fuit	hachor
VI	fuit	scrude
VI	fuit	ragau
VI	fuit	faleg
VI	fuit	eber
VI	fuit	sala
VI	fuit	cainan

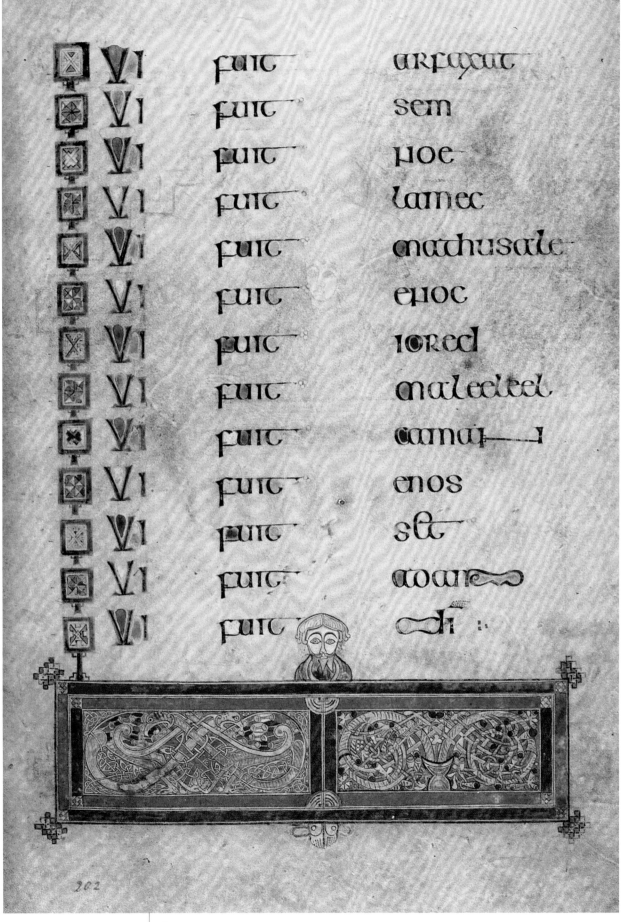

VI fuit arfaxat

VI fuit sem

VI fuit noe

VI fuit lamec

VI fuit mathusale

VI fuit enoc

VI fuit iored

VI fuit malecleel

VI fuit camai

VI fuit enos

VI fuit seth

VI fuit adam

VI fuit dī

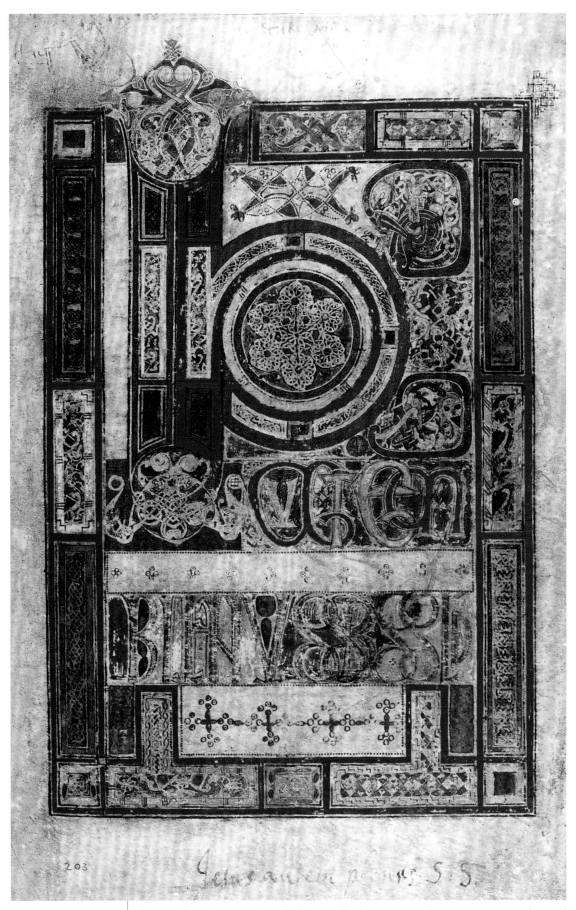

f.203r. Christ Begins to Preach the Gospel. This ornamental text page contains the words from Luke 4:1: IHS autem plenus SP [Spiritu] SSCO [Sancto] *("Now Jesus, full of the Holy Spirit") with which Christ's mission begins after he rebukes Satan.*

qui in modico iniquus est i in maio
ri iniquus est si ergo in iniquo mamo
ne fideles non fuistis quod uestrum est
quis credat uobis i si in alieno fide
les non fuistis quod uestrum qui dabit uo
bis Nemo seruus potest duobus do
minis seruire aut enim unum odic
et alterum diliget aut unum adherebit
et alterum contempnit non potestis do seruire
Audiebant haec omnia farisaei qui
erant auari et deridebant illum
et ait illis uos estis qui iustificatis
uos coram hominib: ds autem nouit
corda uestra quia quod hominib: al
tum est abominatio est ante dm:
lex et prophetae usque ad iohan
nem et ex eo regnum di euangeli

f.253v. Luke 16:10–16. The initial "N" in the word nemo *is formed by two men facing*
each other, illustrating the message of the verse: Nemo servus potest duobus dominis servire
("No servant can serve two masters"). © VISIPIX.COM

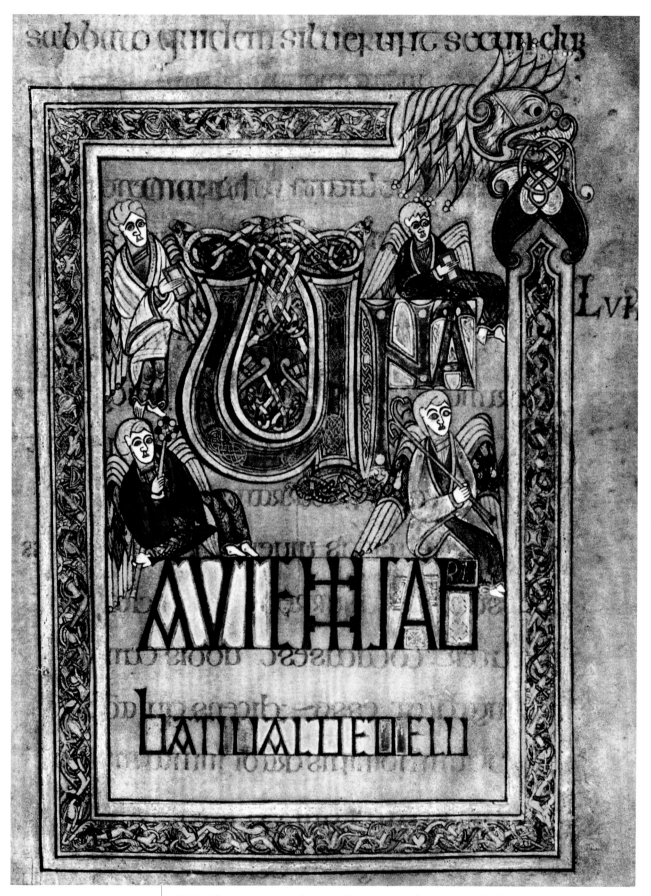

f.285r. The Ascension. Luke 24:1 This ornamental text page is the beginning of the Ascension story and contains the words una autem sabbati ualde de lu[culo] *("But on the first day of the week"). Depicted are four angels. They are perhaps representations of the Archangels Gabriel, Michael, Raphael, and Uriel.* ©VISIPIX.COM

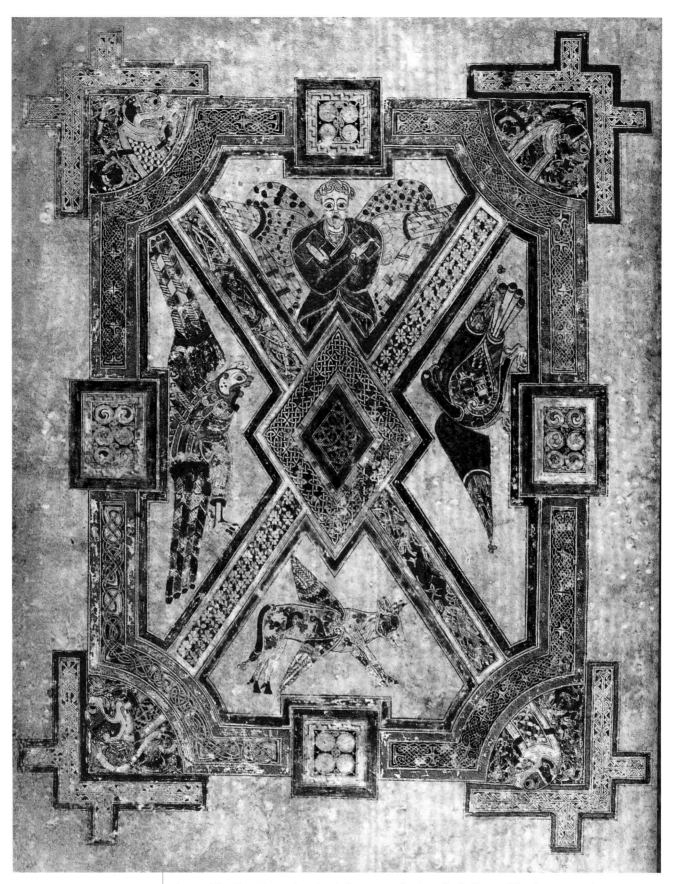

f.290v. The Four Evangelists Symbols page in the Gospel of John. Unlike the rectangular framed Evangelists symbol pages in Matthew and Mark, this page has a unique presentation using a saltier frame. This diagonal motif seems to be repeated in the fashion in which Matthew is holding two books. Here we may be seeing a composite representation of the "Osiris pose." © VISIPIX.COM

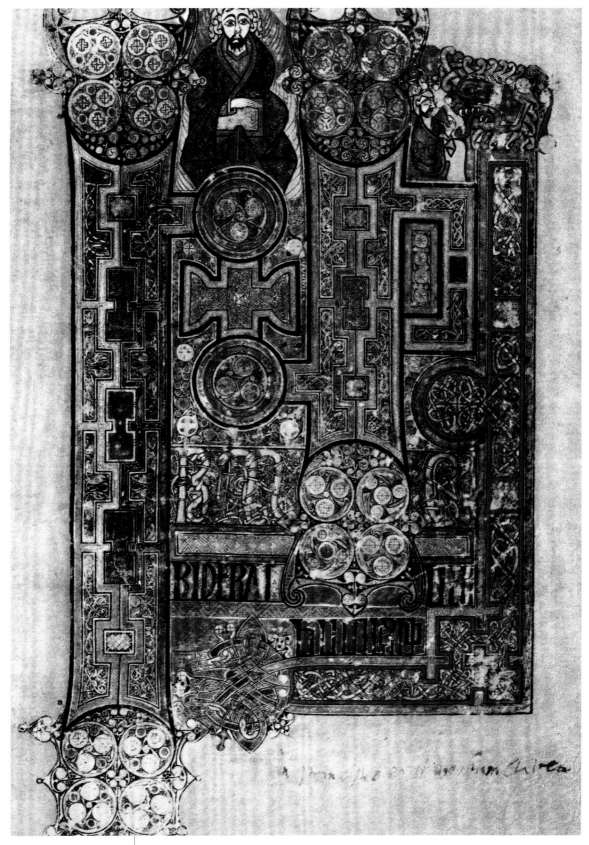

f.292r. The introductory page of the Gospel of John. This ornamental text page contains the opening words of John: In principio erat Verbum et Verbum ("In the beginning was the Word and the Word"). There is an anthropomorphic image of John at the upper right holding a chalice. At the center top we see a larger image which may represent not only the Evangelist but also a figurative image symbolizing the Word itself. This page is the last surviving full page illumination in John. There may have been others that were destroyed when the manuscript's covers were torn off during its theft in the early eleventh century. ©VISIPIX.COM

f.339r. John: 16:32–17:12. The last folio in the Book of Kells *clearly shows the damage from the theft of the manuscript.* ©VISIPIX.COM

THE
BOOK of KELLS

 1r

 1v

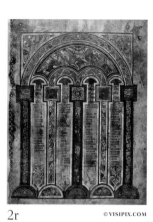 2r

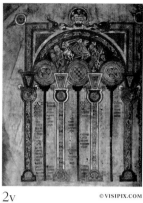 2v

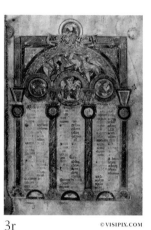 3r

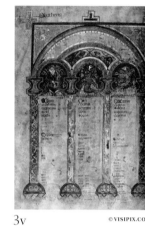 3v

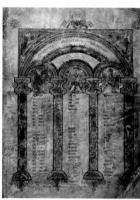 4r

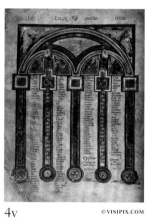 4v

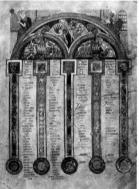 5r

 5v

 6r

6v

7r

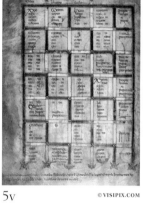 7v

 8r

 8v

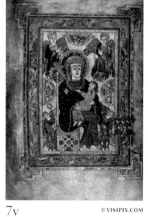

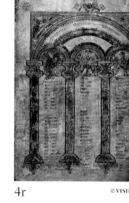

9r
9v
10r
10v

11r
11v
12r
12v

13r
13v
14r
14v

15r
15v
16r
16v

17r ©VISIPIX.COM

17v ©VISIPIX.COM

18r ©VISIPIX.COM

19r ©VISIPIX.COM

19v ©VISIPIX.COM

20r ©VISIPIX.COM

20v ©VISIPIX.COM

21v ©VISIPIX.COM

22r ©VISIPIX.COM

22v ©VISIPIX.COM

23r ©VISIPIX.COM

23v ©VISIPIX.COM

24r ©VISIPIX.COM

24v ©VISIPIX.COM

25r ©VISIPIX.COM

25v ©VISIPIX.COM

26r

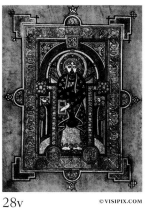

26v

27r

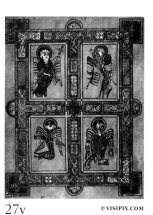

27v

28r

28v

29r

29v

30r

30v

31r

31v

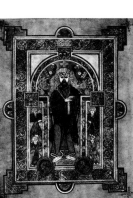

32r

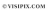

32v

33r

33v

34r
34v
35r
35v

36r
36v
37r
37v

38r
38v
39r
39v

40r
40v
41r
41v

42r © VISIPIX.COM 42v © VISIPIX.COM 43r © VISIPIX.COM 43v © VISIPIX.COM

44r © VISIPIX.COM 44v © VISIPIX.COM 45r © VISIPIX.COM 45v © VISIPIX.COM

46r © VISIPIX.COM 47r © VISIPIX.COM 47v © VISIPIX.COM 48r © VISIPIX.COM

48v © VISIPIX.COM 49r © VISIPIX.COM 49v © VISIPIX.COM 50r © VISIPIX.COM

50v © VISIPIX.COM

51v © VISIPIX.COM

52r © VISIPIX.COM

52v © VISIPIX.COM

53r © VISIPIX.COM

53v © VISIPIX.COM

54r © VISIPIX.COM

54v © VISIPIX.COM

55r © VISIPIX.COM

55v © VISIPIX.COM

56r © VISIPIX.COM

56v © VISIPIX.COM

57r © VISIPIX.COM

57v © VISIPIX.COM

58r © VISIPIX.COM

58v © VISIPIX.COM

59r © VISIPIX.COM

59v © VISIPIX.COM

60r © VISIPIX.COM

60v © VISIPIX.COM

61r © VISIPIX.COM

61v © VISIPIX.COM

62r © VISIPIX.COM

62v © VISIPIX.COM

63r © VISIPIX.COM

63v © VISIPIX.COM

64r © VISIPIX.COM

64v © VISIPIX.COM

65r © VISIPIX.COM

65v © VISIPIX.COM

66r © VISIPIX.COM

66v © VISIPIX.COM

67r

67v

68r

68v

69r

69v

70r

70v

71r

71v

72r

72v

73r

73v

74r

74v

75r © VISIPIX.COM

75v © VISIPIX.COM

76r © VISIPIX.COM

76v © VISIPIX.COM

77r © VISIPIX.COM

77v © VISIPIX.COM

78r © VISIPIX.COM

78v © VISIPIX.COM

79r © VISIPIX.COM

79v © VISIPIX.COM

80r © VISIPIX.COM

80v © VISIPIX.COM

81r © VISIPIX.COM

81v © VISIPIX.COM

82r © VISIPIX.COM

82v © VISIPIX.COM

83r © VISIPIX.COM
83v © VISIPIX.COM
84r © VISIPIX.COM
84v © VISIPIX.COM

85r © VISIPIX.COM
85v © VISIPIX.COM
86r © VISIPIX.COM
86v © VISIPIX.COM

87r © VISIPIX.COM
87v © VISIPIX.COM
88r © VISIPIX.COM
88v © VISIPIX.COM

89r © VISIPIX.COM
89v © VISIPIX.COM
90r © VISIPIX.COM
90v © VISIPIX.COM

91r

91v

92r

92v

93r

93v

94r

94v

95r

95v

96r

97r

97v

98r

98v

99r

99v © VISIPIX.COM

100r © VISIPIX.COM

100v © VISIPIX.COM

101r © VISIPIX.COM

101v © VISIPIX.COM

102r © VISIPIX.COM

102v © VISIPIX.COM

103r © VISIPIX.COM

103v © VISIPIX.COM

104r © VISIPIX.COM

104v © VISIPIX.COM

105r © VISIPIX.COM

105v © VISIPIX.COM

106v © VISIPIX.COM

107r © VISIPIX.COM

107v © VISIPIX.COM

108r © VISIPIX.COM

108v © VISIPIX.COM

109r © VISIPIX.COM

109v © VISIPIX.COM

110r © VISIPIX.COM

110v © VISIPIX.COM

111r © VISIPIX.COM

111v © VISIPIX.COM

112r © VISIPIX.COM

112v © VISIPIX.COM

113r © VISIPIX.COM

113v © VISIPIX.COM

114r © VISIPIX.COM

114v © VISIPIX.COM

115r © VISIPIX.COM

115v © VISIPIX.COM

116r © VISIPIX.COM 116v © VISIPIX.COM 117r © VISIPIX.COM 117v © VISIPIX.COM

118r © VISIPIX.COM 118v © VISIPIX.COM 119v © VISIPIX.COM 120r © VISIPIX.COM

120v © VISIPIX.COM 121r © VISIPIX.COM 122r © VISIPIX.COM 122v © VISIPIX.COM

123r © VISIPIX.COM 123v © VISIPIX.COM 124r © VISIPIX.COM 124v © VISIPIX.COM

125r

125v

126r

126v

127r

127v

128r

128v

129r

129v

130r

130v

131r

131v

132r

132v

133r 133v 134r 134v

135r 135v 136r 136v

137r 137v 138r 138v

139r 139v 140r 140v

141r

141v

142r

142v

143r

143v

144r

144v

145r

145v

146r

146v

147r

147v

148r

149r

149v © VISIPIX.COM 150r © VISIPIX.COM 150v © VISIPIX.COM 151r © VISIPIX.COM

151v © VISIPIX.COM 152r © VISIPIX.COM 152v © VISIPIX.COM 153r © VISIPIX.COM

153v © VISIPIX.COM 154r © VISIPIX.COM 154v © VISIPIX.COM 155r © VISIPIX.COM

155v © VISIPIX.COM 156r © VISIPIX.COM 156v © VISIPIX.COM 157r © VISIPIX.COM

157v
158r
158v
159r

159v
160r
160v
161r

161v
162r
162v
163r

163v
164r
164v
165r

165v © VISIPIX.COM

166r © VISIPIX.COM

166v © VISIPIX.COM

167r © VISIPIX.COM

167v © VISIPIX.COM

168r © VISIPIX.COM

168v © VISIPIX.COM

169r © VISIPIX.COM

169v © VISIPIX.COM

170r © VISIPIX.COM

170v © VISIPIX.COM

171r © VISIPIX.COM

171v © VISIPIX.COM

172r © VISIPIX.COM

172v © VISIPIX.COM

173r © VISIPIX.COM

173v

174r

174v

175r

175v

176r

176v

177r

177v

178r

178v

179r

179v

180r

180v

181r

181v ©VISIPIX.COM

182r ©VISIPIX.COM

182v ©VISIPIX.COM

183r ©VISIPIX.COM

183v ©VISIPIX.COM

184r ©VISIPIX.COM

184v ©VISIPIX.COM

185r ©VISIPIX.COM

185v ©VISIPIX.COM

186r ©VISIPIX.COM

186v ©VISIPIX.COM

187r ©VISIPIX.COM

187v ©VISIPIX.COM

188r ©VISIPIX.COM

188v ©VISIPIX.COM

189r ©VISIPIX.COM

189v · 190r · 190v · 191r · 191v · 192r · 192v · 193r · 193v · 194r · 194v · 195r · 195v · 196r · 196v · 197r

197v

198r

198v

199r

199v

200r

200v

201r

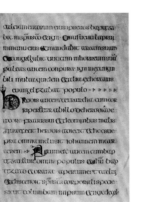

201v

202r

202v

203r

203v

204r

204v

205r

205v © VISIPIX.COM 206r © VISIPIX.COM 206v © VISIPIX.COM 207r © VISIPIX.COM

207v © VISIPIX.COM 208r © VISIPIX.COM 208v © VISIPIX.COM 209r © VISIPIX.COM

209v © VISIPIX.COM 210r © VISIPIX.COM 210v © VISIPIX.COM 211r © VISIPIX.COM

211v © VISIPIX.COM 212r © VISIPIX.COM 212v © VISIPIX.COM 213r © VISIPIX.COM

213v

214r

214v

215r

215v

216r

216v

217r

217v

218r

218v

219r

219v

220r

221r

221v

222r © VISIPIX.COM 222v © VISIPIX.COM 223v © VISIPIX.COM 224r © VISIPIX.COM

224v © VISIPIX.COM 225r © VISIPIX.COM 225v © VISIPIX.COM 226r © VISIPIX.COM

226v © VISIPIX.COM 227r © VISIPIX.COM 227v © VISIPIX.COM 228r © VISIPIX.COM

228v © VISIPIX.COM 229r © VISIPIX.COM 229v © VISIPIX.COM 230r © VISIPIX.COM

230v © VISIPIX.COM

231r © VISIPIX.COM

231v © VISIPIX.COM

232r © VISIPIX.COM

232v © VISIPIX.COM

233r © VISIPIX.COM

233v © VISIPIX.COM

234r © VISIPIX.COM

234v © VISIPIX.COM

235r © VISIPIX.COM

235v © VISIPIX.COM

236r © VISIPIX.COM

236v © VISIPIX.COM

237r © VISIPIX.COM

237v © VISIPIX.COM

238r © VISIPIX.COM

238v © VISIPIX.COM

239r © VISIPIX.COM

239v © VISIPIX.COM

240r © VISIPIX.COM

240v © VISIPIX.COM

241r © VISIPIX.COM

241v © VISIPIX.COM

242r © VISIPIX.COM

242v © VISIPIX.COM

243r © VISIPIX.COM

243v © VISIPIX.COM

244r © VISIPIX.COM

244v © VISIPIX.COM

245r © VISIPIX.COM

245v © VISIPIX.COM

246r © VISIPIX.COM

246v 247r 247v 248r

248v 249r 250r 250v

251r 251v 252r 252v

253r 253v 254r 254v

255r

255v

256r

256v

257r

257v

258r

258v

259r

259v

260r

260v

261r

261v

262r

262v

263r © VISIPIX.COM

263v © VISIPIX.COM

264r © VISIPIX.COM

264v © VISIPIX.COM

265r © VISIPIX.COM

265v © VISIPIX.COM

266r © VISIPIX.COM

266v © VISIPIX.COM

267r © VISIPIX.COM

267v © VISIPIX.COM

268r © VISIPIX.COM

268v © VISIPIX.COM

269r © VISIPIX.COM

269v © VISIPIX.COM

270r © VISIPIX.COM

270v © VISIPIX.COM

271r © VISIPIX.COM
271v © VISIPIX.COM
272r © VISIPIX.COM
272v © VISIPIX.COM

273r © VISIPIX.COM
273v © VISIPIX.COM
274r © VISIPIX.COM
274v © VISIPIX.COM

275r © VISIPIX.COM
275v © VISIPIX.COM
276r © VISIPIX.COM
276v © VISIPIX.COM

277r © VISIPIX.COM
277v © VISIPIX.COM
278r © VISIPIX.COM
278v © VISIPIX.COM

279r

279v

280r

280v

281r

281v

282r

282v

283r

283v

284r

284v

285r

285v

286r

286v

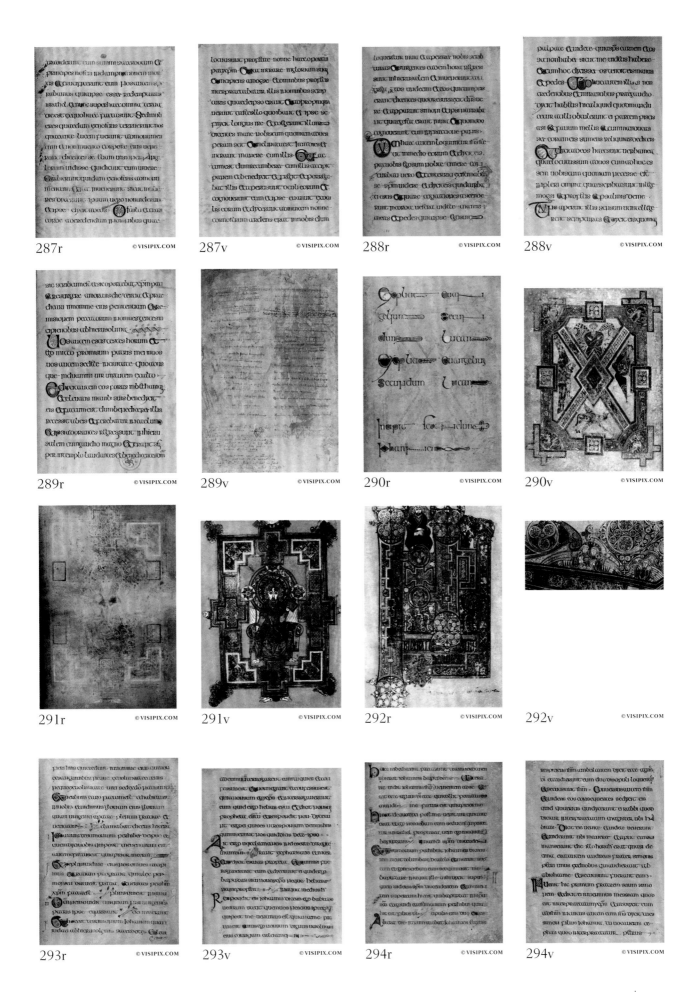

287r © VISIPIX.COM

287v © VISIPIX.COM

288r © VISIPIX.COM

288v © VISIPIX.COM

289r © VISIPIX.COM

289v © VISIPIX.COM

290r © VISIPIX.COM

290v © VISIPIX.COM

291r © VISIPIX.COM

291v © VISIPIX.COM

292r © VISIPIX.COM

292v © VISIPIX.COM

293r © VISIPIX.COM

293v © VISIPIX.COM

294r © VISIPIX.COM

294v © VISIPIX.COM

295r © VISIPIX.COM
295v © VISIPIX.COM
296r © VISIPIX.COM
296v © VISIPIX.COM

297r © VISIPIX.COM
297v © VISIPIX.COM
298r © VISIPIX.COM
298v © VISIPIX.COM

299r © VISIPIX.COM
299v © VISIPIX.COM
300r © VISIPIX.COM
300v © VISIPIX.COM

301r © VISIPIX.COM
301v © VISIPIX.COM
302r © VISIPIX.COM
302v © VISIPIX.COM

303r

303v

304r

304v

305r

305v

306r

306v

307r

307v

308r

308v

309r

309v

310r

310v

311r

311v

312r

312v

313r

313v

314r

314v

315r

315v

316r

316v

317r

317v

318r

318v

319r © VISIPIX.COM

319v © VISIPIX.COM

320r © VISIPIX.COM

320v © VISIPIX.COM

321r © VISIPIX.COM

322r © VISIPIX.COM

322v © VISIPIX.COM

323r © VISIPIX.COM

323v © VISIPIX.COM

324v © VISIPIX.COM

325r © VISIPIX.COM

325v © VISIPIX.COM

326r © VISIPIX.COM

326v © VISIPIX.COM

327r © VISIPIX.COM

327v © VISIPIX.COM

328r

328v

329r

329v

330r

330v

331r

331v

332r

332v

333r

333v

334r

334v

335r

335v

336r

336v

337r

337v

338r

338v

339r

339v